INDIA
PUBLIC PLACES PRIVATE SPACES
Contemporary Photography and Video Art

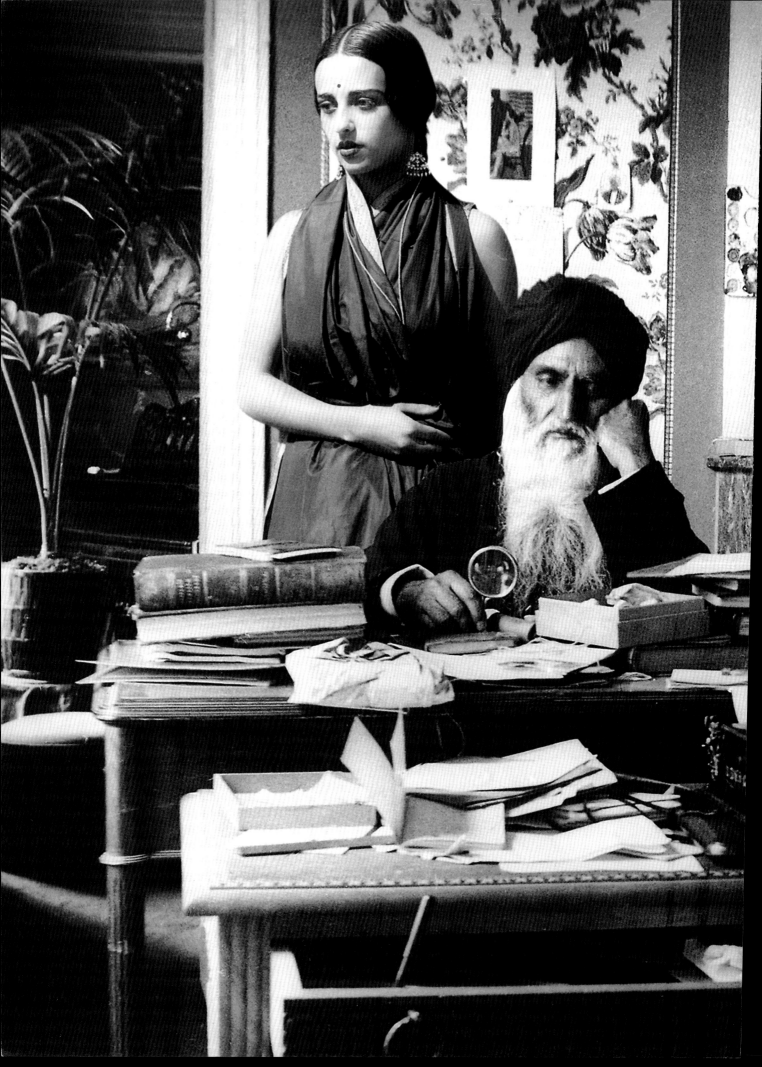

INDIA

PUBLIC PLACES PRIVATE SPACES

Contemporary Photography and Video Art

Gayatri Sinha Paul Sternberger

With contributions by
Barbara London and Suketu Mehta

Brian Drolet, Editor

published by

80 GALLERIES OF INSPIRATION & EXPLORATION
THE NEWARK MUSEUM
NewarkMuseum.org

in association with *Marg* publications

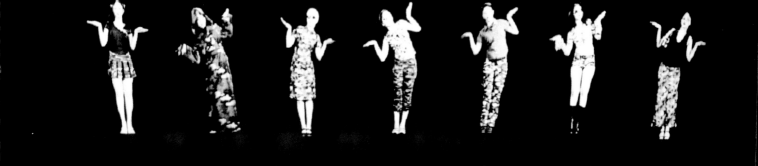

PRODUCED BY Marg Publications, Mumbai, India
EDITORIAL Savita Chandiramani, Gayatri W. Ugra, Arnavaz K. Bhansali
TEXT EDITOR Rivka Israel
DESIGNER Naju Hirani
PRODUCTION Gautam V. Jadhav, Vidyadhar R. Sawant

PROCESSING Reproscan, Mumbai
PRINTING Silverpoint Press, Mumbai

Published by THE NEWARK MUSEUM, NEWARK, NEW JERSEY, USA
in association with MARG PUBLICATIONS, MUMBAI, INDIA

ISBN 10: 81-85026-82-3
ISBN 13: 978-81-85026-82-4
Library of Congress Catalog Card Number: 2007-340005

CONTENTS

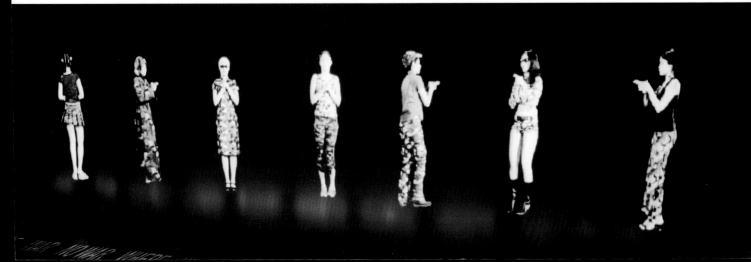

The Newark Museum gratefully acknowledges
the generous support of

PROVIDENT BANK
Foundation

E. Rhodes and Leona B. Carpenter Foundation

Poonam Khubani

Marguerite and Kent Srikanth Charugundla
The Charugundla Foundation

The Hite Foundation

New Jersey Council for the Humanities

Asian Cultural Council

Dr. Umesh Gaur and Dr. Sunanda Gaur

Continental Airlines

The Newark Museum, a not-for-profit museum of art, science and education, receives operating support from the City of Newark, the State of New Jersey, the New Jersey State Council on the Arts / Department of State – a partner agency of the National Endowment for the Arts, the New Jersey Cultural Trust, the Prudential Foundation, the Geraldine R. Dodge Foundation, the Victoria Foundation, and other corporate, foundation and individual donors. Funds for acquisitions and activities other than operations are provided by members and other contributors.

Director's Statement

In part the result of a period of unprecedented economic development and cultural change in India, the exhibition *INDIA: Public Places, Private Spaces – Contemporary Photography and Video Art* recognizes the achievements of photographers and video artists working in the country during these last twenty years. It is highly appropriate for The Newark Museum to debut this groundbreaking exhibition, given the equally unprecedented growth and influence of the Indian diaspora in the U.S., New Jersey being home to one of the largest Indian-American communities.

The Newark Museum's presentations of Asian Indian culture began with a pioneering 1928 exhibition, *East Indian Costumes and Articles*. Major examples of Indian sacred art were added to the Museum's collections through the 1960s, 1970s and 1980s, and three permanent galleries devoted to the art of South Asia were completed in 1989. The collection has recently

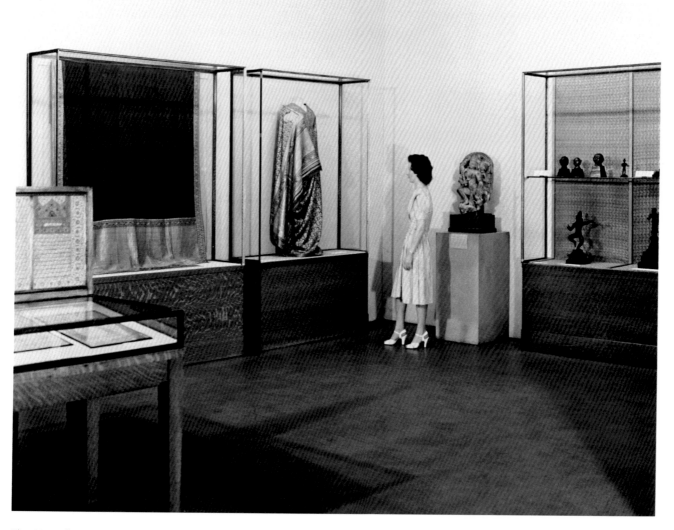

The Newark Museum has exhibited the arts of India since its earliest years, beginning in 1928. This 1942 photograph is a view of the Museum's exhibition *Indian and Persian Decorative Arts from the Jaehne Collection*

expanded to include prehistoric ceramic and bronze artifacts and the everyday traditional arts of urban, rural and tribal peoples throughout South Asia, culminating in the 1995–96 traveling exhibition, *Cooking for the Gods: The Art of Home Ritual in Bengal*, a landmark project guided by Curator of Asian Art, Valrae Reynolds.

INDIA: Public Places, Private Spaces brings established masters like photographer Raghu Rai together with younger artists now defining themselves through experimental new media. We thank the twenty-five participating artists for sharing with an international audience their explorations interweaving politics, family history and personal identity in the context of a rapidly changing society.

On behalf of the trustees and staff of The Newark Museum, I thank all whose encouragement and generous participation have guided the development of this exhibition, among them Dr. Umesh Gaur, who first proposed a project of this scale and introduced us to the exceptional scholars who became the exhibition's curators – Gayatri Sinha, independent curator and scholar in India, and Paul Sternberger, Associate Professor of Art History at Rutgers University. Zette Emmons, Manager of Traveling Exhibitions at The Newark Museum, has provided special expertise as project director, producing a most luminous exhibition and an important book. We are honored that distinguished author Suketu Mehta and Barbara London, Associate Curator, Department of Media, The Museum of Modern Art, contributed to the catalog, expertly edited by Brian Drolet. Many aspects of *INDIA: Public Places, Private Spaces* were managed with great sensitivity by Alison Edwards, Director of Special Projects.

Of particular meaning to The Newark Museum are the members of the Indian Advisory Committee, beginning with trustee Poonam Khubani. New Jersey State Assemblyman, The Honorable Upendra J. Chivukula, has given consistent affirmation, as has The Honorable Neelam Deo, Consul General in the Consulate General of India, New York. The committee members' names are listed in this publication.

Together we recognize the all-important financial support of The Provident Bank, The Provident Bank Foundation, the E. Rhodes and Leona B. Carpenter Foundation, Poonam Khubani, Marguerite and Kent Srikanth Charugundla and The Charugundla Foundation, The Hite Foundation, Asian Cultural Council, the New Jersey Council for the Humanities and Continental Airlines. All Museum activities are made possible by the generous support of the City of Newark, the State of New Jersey and the New Jersey State Council on the Arts / Department of State.

Of course an exhibition on this scale requires many avatars, and we are especially grateful for the enthusiasm of Newark Museum Chief Operating Officer, Meme Omogbai, who has joined a business women's delegation to create Indo-U.S. partnerships. I also take this opportunity to recognize the fine work of Newark Museum registrars, exhibition designers, and the many marketing, development and editorial staff members who embraced this project so fully.

Mary Sue Sweeney Price
Director
The Newark Museum

8

Foreword

In my childhood in India, a photograph was a family affair. You did not just take a snapshot, you oiled your hair and pressed your shirt and posed stiffly against an appropriately scenic background – a fort, a mountain – and allowed someone to freeze that unreal moment in time. My grandfather bought me my first camera in the fifth grade, an Agfa Click III, essentially a box camera which I used sparingly; the black-and-white rolls of film, and the costs of developing, were impossibly high for my middle-class family. The cost dictated the image; you posed one or more friends or family members, preferably in front of a garden, a sunset or a sea, with great deliberation. Nothing could be incidental; all clutter – a stray dog, an untucked shirt, passers-by – was rigorously eliminated from the frame. In India, I was trying to shut out the crowd.

The problem with viewing India through a non-fiction lens is that there is too much clutter. How, in a photograph or video, does one cope with the extraordinary barrage of visual stimulus that rushes upon us from all sides? How does one assemble the psychedelic chaos of the streetscape – bonesetter, Mercedes, kabab-seller, Bollywood poster, open sewer, schoolgirls – into a statement about anything? You might be grateful for owning only a box camera, that would force you to concentrate on what was most important – the decisive image. The answer for some artists is to create deeply private spaces that shut out the crowd. For others, their work is a panorama, a simulacrum, of the whole, with a minimal imposition of the artist's own interpretation; what you see is what *you* see.

There are certain themes that become apparent upon a viewing of the works in this wide-ranging show: the dichotomy between urban and rural India, political violence, the changing position of women, the juxtaposition of private space and public spectacle. There is also a movement from black-and-white to color. I remember standing next to Raghubir Singh at an Asia Society reception of his work; an eager young student approached him and demanded to know why, unlike many of the great documentary photographers, Raghubir did not work in black-and-white. "Because I see in color," Raghubir responded. But it took Raghubir's masterful eye to see the true color in the country, color that was not merely vivid.

The artists in this show are at home in the world. They invoke contemporary and historical events from the Ahmedabad riots to the Kashmir conflict to the international diamond trade; one is struck by their confidence in taking on the world. Many contemporary Indian artists choose to engage robustly with social and political issues; many do not. The surest sign of the maturity of Indian photography is that there can be no sweeping statements about a school or a group that is representative of the lot of them; nobody's publishing manifestos.

That is because they know that everything you can say about India is true and false – simultaneously. Yes, it has terrible religious violence, as many of them document. But yes, this democracy which is 82 percent Hindu is currently led by a Sikh prime minister, a Muslim president, and an Italian Catholic who's head of the governing coalition. Yes, it is an economic superpower of the twenty-first century, but yes, 40 percent of the population is illiterate and levels of child malnutrition are higher than sub-Saharan Africa. Such a show's gaze upon India must encompass all these dichotomies, and then go beyond.

India is an assault on the senses; its best visual artists attempt to mediate that assault. In such a turbulent world, how does one create islands of intimacy? How does one rescue what is most powerfully human from the whirl and tumult of the ever-present Indian crowd? In the cities of India, the greatest luxury is solitude. The photograph, in the hands of these most skilled artists, is a reversion: the lens is aimed deep within the photographer.

Suketu Mehta

New Forms

BARBARA LONDON

The political and cultural upheavals of the 1960s saw the emergence of new artistic forms, made with new creative tools. Most notably, reasonably priced, consumer-grade video cameras and editing systems, crude by today's standards, permitted innovative "alternative" practices. Very much in tune with the rebellious and revolutionary spirit of the times, the art created with these new tools was difficult to collect or exhibit in traditional spaces. It was more suited to seat-of-the pants, artist-run, rough-and-ready venues that were sprouting up in urban centers. Some artists produced linear video that paralleled independent filmmaking. Others developed room-scale installations, often with a live video camera designed specifically for the particular exhibition space (preferably not a white cube of a room). At the time "performance art" was not yet a term. In New York, Joan Jonas called her work "pieces" or "concerts," in which she performed with a video camera and a real time image of herself on a monitor. Critics called Bruce Nauman and Vito Acconci "body artists." Yvonne Rainer created dance as the most minimal of actions before she turned to film. In theater, Richard Forman worked with the spareness of Samuel Beckett and extended and contracted time in the theatrical moment.

Coming on the heels of the 1968 student unrest and the rise of the women's movement, installation started out with an experimental edge. Artists intentionally provoked and challenged the status quo with the new video forms. Many intentionally turned their backs on television and considered broadcast networks the enemy. The notions of selling or collectability were of little concern to most. These artists lived from moment to moment with their projects, which were made for "now." If they presented an installation a second time, they drastically modified it for a new situation. Artists often gained access to equipment by going on the road to produce and install new pieces at international festivals or by doing residencies at art schools. Meanwhile, museums wrestled with how to adapt the ever-evolving, mutable installation form to their galleries.

In this new art form starting with a clean slate, female and male artists were on equal footing. They approached installation from a wide range of disciplines – painting and sculpture in particular. Many turned to a variety of media to illuminate and activate a space: small-format video and sound, Super-8 film, slides, even the camera obscura.

Over the years technology has advanced considerably. Equipment has become less expensive, more versatile and ubiquitous. Projectors are now a common display format, with brighter, larger and sharper images. High-resolution digital flat screens are replacing boxy analog monitors. Sound as an essential component is more malleable and spatial, and interactivity is an option. Institutions and collectors are more comfortable and better equipped to handle a work's technical aspects and preservation requisites. Museums integrate video work into their contemporary galleries and construct dedicated spaces, as required by specific projects. Biennials, as a matter of course, devote a large portion of their exhibition spaces to installation.

In India, independent media activity began with the satellite and cable television revolution in the 1980s. With a sense of political urgency amid their country's complex and turbulent backdrop, the earliest practitioners had a connection to local documentary photography and film traditions. As India's economy developed in the 1990s, a cultural shift ensued. Nalini Malani (b. 1947) and Vivan Sundaram (b. 1943) – artists who already had established reputations in the visual arts – started to use video, adding time as

another dimension to their new installation work. They also faced the same problem confronted by early media artists in the West: their access to gallery spaces and exhibition equipment was limited.

Today the situation has vastly improved, with the burgeoning contemporary art market in New Delhi, Mumbai and Bangalore, and the rise of commercial galleries and alternative exhibition venues. The younger generation readily works with video and media technologies, having grown up with greater access to consumer tools that are more widely available. They attend art schools both at home and abroad, and often draw upon local subject matter, as Sonia Khurana (b. 1968) effectively did in articulating an authentic voice with her video *Mona's Song* (2004).

India has become a center of the information technology industry. The Internet plays a vital role, facilitating an array of booming cultures driven by different imperatives. The film and music industries are experimenting with new formats and content, call centers and other new service industries are thriving, and the community of software developers is nimbly moving ahead. Each of these sectors, which employs "creatives," is closely tied to a vast global network. Some artists in India pursue commercial information technology careers before turning full-time to their art. Shilpa Gupta (b. 1976) is a versatile programmer who creates interactive installations that engage viewers with notions of role-playing and spectatorship, often with life-size projections of herself.

Artists such as Ranbir Kaleka, Vivan Sundaram, Sonia Khurana, Shilpa Gupta and Nalini Malani, among many others, pursue media to create distinctive projects rich in metaphor. They are what Malani describes as being "part of a committed cross-national artists' community, dissidents in the structures of established power relations with social / environmental protest being a major concern" in many of their works.

For these artists, video is a viable, encompassing and flexible form. Coming from a culture with a multiplicity of traditions, their combinations of old and new content and materials result in inventive amalgamations. New media solutions from the Indian subcontinent will certainly continue to invigorate contemporary art practice in other parts of the world for a long time to come.

Pursuit of Dreams

Contemporary Contexts in Photography and Video Art in India

GAYATRI SINHA

Contemporary India as a subject of photography has proved oddly elusive. The volume of photographic material generated in the pre-Independence era, from the early 1850s until the mid-twentieth century, created an enduring visual imagery of India. That includes depictions of it as an oriental locus of fabled wealth and poverty, having a people both pious and ungovernable, all as extreme as the vicissitudes of the Indian landscape. Photographers of the period, both European and Indian, were frequently guided by the ideal of the "picturesque," which conformed to the principles of British landscape painting.[1] At the same time, photography solidified the imperial view of India. Photography curator and author John Falconer, speaking of the rich documentation of Indian cities in the nineteenth century, writes, "The visual record is necessarily partial since the photographer's vision and choice of subject matter was determined as much by political standpoint as aesthetic judgment."[2] From Independence in 1947 to the present, the terms of reference have critically changed to accommodate the struggle for recognition of emergent groups and polyvalent energies within the subcontinent. At the same time, the photographs of India seen in North America or Europe have an exhausting predictability of themes relating to Third World economies and disaster, communal strife, fractious border disputes, child labor.[3] On another register of exaggeration, the tourist catalog of "incredible India" and her inviting beauty has grown to include another chromatic seduction, of Bollywood and its reaffirmation of a fabulous imagined vision of India.

Curating an exhibition of contemporary Indian photography and video calls into question the reading of Indian society itself. Of all the arts in India, photography has proved the most protean in its adaptability to class and nation, traversing popular art and issues of identity. Yet its history has not been mapped, nor the location of photographers in the language of the Indian modern fully realized. A schism between kinds of representation of public and private spaces is not fortuitous. As photography progresses from the sphere of the "other" to the "self," what becomes apparent is the instrumentality of the camera as a tool of historical documentation. Postcolonial photography alters the gaze from confrontation to complicit observer. In the postcolonial condition, the primary position of the gaze is cultural; it only subsequently flows into the binary of the public and the private.

INDIAN PHOTOGRAPHY – A BRIEF HISTORY

Ever since F. Shranzhofer opened the first known professional photo studio in Calcutta in 1849, Indians readily embraced photography, and were avid for the new medium.[4] Indian cities already had a well-documented history of printing; by the late nineteenth century, the city of Calcutta boasted 300 printing presses.[5] The printed book, almanac and newspaper bolstered the aspirations of a subject people struggling with issues of literacy and modernity. They penetrated the zenana (all-women) quarters, carrying news of the larger world. Print media became an instrument of both the British colonialist and the nationalist press. Photography, the new invention, became a valuable and contested addition to the demand for the printed journal.

Since the First War of Independence against British colonial rule in 1857, the British press used the instrumentality of the camera as a tool in the imperialist argument. In response, from the 1860s and '70s, the Indian press grew phenomenally.[6] Within a

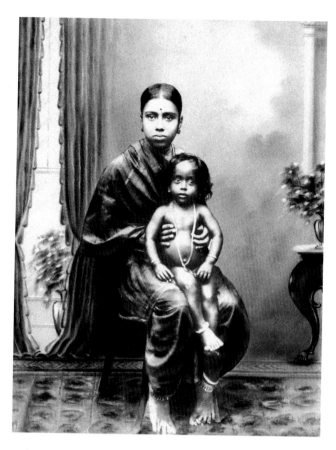

Unknown photographer, *Mother and Child against Painted Backdrop*, Tamil Nadu, India, early twentieth century, silver gelatin print, collection of Gayatri Sinha

few decades, Indian nationalist leaders such as M.K. Gandhi, M.A. Jinnah, Bal Gangadhar Tilak and Aurobindo Ghosh all owned newspapers that vociferously presented the Indian viewpoint. The raging Bengal famine of 1943 was recorded in moving detail by photographer Sunil Janah for the Left party paper, *People's War*. The photograph in this context was already seen as partisan and interpretive. With Independence and Partition in 1947, the new nation faced the compelling need for the dissemination of the printed image. The government established the Press Information Bureau in the late 1940s to represent the nascent history of the new nation. Meanwhile, portraits of Indian leaders crowded into public spaces, offices, institutions, postage stamps and documentary films.

PUBLIC PLACES – NEW DOCUMENTARY POSITIONS

Inevitably, a consideration of the "public" and the "private" invites analysis. What is the "public" and how does it translate as a visual fact? Is there a culturally coherent, homogeneous Indian public? Or quantifiable public spaces? Instructively, German philosopher and sociologist Jürgen Habermas, writing on the public sphere, makes a distinction between "life world" and "system." "Life world" refers to the public sphere of the individual, while "system" refers to the market economy and state apparatus. These two domains and their intersections virtually determine the representation of the public within the context of this exhibition.[7]

The history of photography in India coincides and changes course with Indian social history. Critical events of the twentieth century led to a shift in style and initiative, most notably with the Bengal famine in 1943, Partition and the making of the new nation state.

Not all Western photographers represented the colonial agenda. In 1947, impending freedom from British rule brought the international press into India, a move that had far-reaching consequences. Margaret Bourke-White's images of Gandhi at the apex of the freedom struggle and the intense engagement of French photographer Henri Cartier-Bresson with the assassination of Gandhi and Partition cleaved into existing forms of representation. Cartier-Bresson's engagement also extended to the occasionally honeyed vulgarisms and small commerce of Indian streets, quacks and charlatans, the poignant passing of the saint Ramana Maharshi, and later the nuclear aspirations of Indira Gandhi.[8] He replaced images of British governor generals, anthropological studies of

tribes and communities, views of the clubhouse, hunts and the shikar, with ones that presented an engaging, humanist view of a climactic period in Indian history.

Arguably, Cartier-Bresson's influence led to the typology of the decisive moment and the unquestioning use of pictorialism in photographing India. But, as Yves Véquaud points out, much of Cartier-Bresson's work was about the ordinary Indian, rendered with humanism and irony rather than photojournalistic objectification.[9] During the 1950s, the leading photographic ethic was one of sympathy with government initiatives. The newly formed Government of India's Press Information Bureau helped disseminate Prime Minister Nehru's new India – images of Soviet collaboration, the Non-Aligned Movement, the Green Revolution, building of dams and steel plants. Homai Vyarawalla, the first Indian woman photojournalist, R.D. Chopra and other photographers of that period enjoyed close proximity to the Nehru-Gandhi family, and portrayed them with unswerving sympathy.[10]

Not all views were sympathetic. A decisive fissure appeared in the decade of wars when conflict with China in 1962, and with Pakistan in 1965 and 1971 (for the independence of Bangladesh) mark a visible distance between the photographer and the state. In the decade of the mid-1960s to '70s the work of Kishor Parekh, who extraordinarily documented the Bangladesh War,[11] S. Paul and Raghu Rai emerges. Parekh's emphasis on the photo essay, S. Paul's quest for the innocence that lingers where the city meets the wheat fields at the edge of a growing Indian urbanism, and Rai's pursuit of an aesthetic of the quotidian, laid the bedrock for a new kind of practice. Meanwhile, another body of work was being rapidly developed by Raghubir Singh, who located his vision in the color and flux of India. Raghubir's astonishing body of work is in the nature of discovery; India in all her chaotic unmapped beauty is laid out for the viewer's gaze.

As a photo editor with *The Statesman* and then *India Today*, Raghu Rai was just a step away from the spectacular theater of Indian politics. His very best

Raghu Rai, *Army Generals Preparing for Indira Gandhi's Funeral*, *Delhi*, 1984, black and white digital inkjet print, 20 x 24 inches, courtesy of the artist

work in this period are photographs chronicling the career of Indira Gandhi until her violent death. Rai's photographs touch the raw nerve of India in the 1980s, as the country was home to people in turmoil, at the brink of momentous change.[12] In his dynamic portraits, Indira appears as the master strategist of modern India, the architect of its nuclear aspirations and a strident postcolonial populism. Rai's photographs mark this climactic moment, as public spaces became sites for conflicting energies to play out. They document Indira's passing into popular art. She recurs as an iconic figure, imaged within the map of India as the symbol of both Shakti and gross violence.[13]

METRO AS LOCUS / CITIZEN AS SUBJECT
The work of Rai and Parekh, in its conflation of popular energy, the press of bodies on the street, and the shadow play of terror and militarism, heralds the new India. It anticipates the multiple documentary voices and sites that emerge as a direct consequence of Indira's politics and the rise of the street as subject.

Not a genre photographer as much as a social commentator, Ram Rahman is quick to understand the honeyed seductions of the fortuitous coming together of religion, politics and the market in the public space. In his photographs of Delhi, the walled

city, Felliniesque circus posters, gods and political leaders are rendered on the same plane. Rahman works to draw out comparisons and hierarchies of images in the visual field, pushing for an anti-aesthetic that militates against the images of "eternal India." Statuary or two-dimensional cut-outs of Indian politicians are framed with deliberate disbalance or even ridicule. Meanwhile, the ordinary figure, frequently in acts of labor, is rendered vital. Working from his own position of relative access, Rahman plays voyeur, tattling on the wealthy with whom he parties. His pictures are an event, but also a critique of that class and its naked aspirations.[14]

India as a growing economic hub breeds contradictions. The bright lights of the metropolis mask the pools of dark spaces beneath the flyover, and the gated colonies of the elite effectively debar the rude energies of the street. Because photography serves so many classes, it allows for a comfortable slippage into the postmodern, dissolving traditional hegemonies of high and low art. Gigi Scaria in *A Day with Sohail and Mariyan,* enters the twilight zone of the nocturnal ragpicker. He debunks the heroic position of the documentary to assume a voice that is not journalistic or critical, but closer to the position of Jean Mohr and someone working from within the

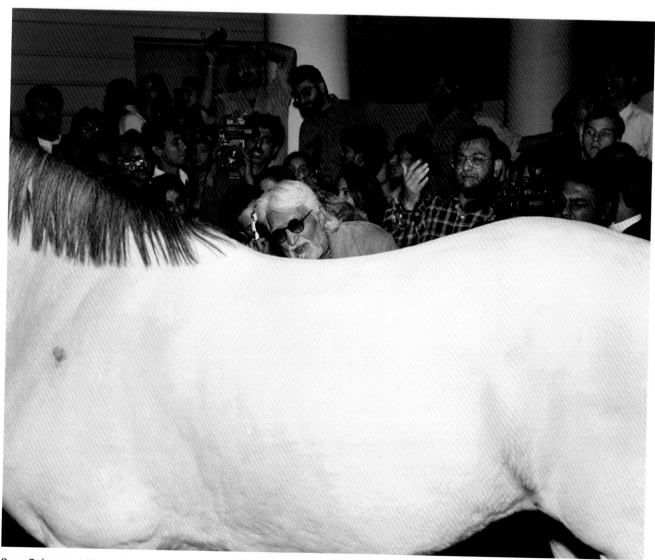

Ram Rahman, *MF Husain Paints a Horse, Delhi*, 1994, silver gelatin print, 16 x 20 inches, courtesy of the artist

Gigi Scaria, *A Day with Sohail and Mariyan*, 2004, single-channel video, 17:00, actors: Sohail Ali and Mariyan Husain, courtesy of the artist

concerns of his subject. Scaria's willingness to engage with the ragpickers from a position of sympathy marks some of the new documentary practices in India.[15]

Other artists invoke India's rising economic indexes through the oblique signs of glitzy packaging and media gloss. Shilpa Gupta works through the simulacrum of conflict and its spectacle, even as she expands into the social and economic crises of Third World polity. The tone Gupta adopts is cheeky and deadpan, and one that mimics the seduction and hard sell of the global market. Some of her previous work: faux Hindu or Muslim blood, bottled and sold by her

in a performative work staged on a Mumbai suburban train (*Blame* 2002–3); diamonds smuggled from Sierra Leone and cut and polished by child labor in India (*diamondsandyou.com*); kidneys sold to international buyers from poor Third World donors (*Your Kidney Supermarket* 2002). All are presented as over-the-counter transactions. In the interactive work *Untitled* (2004–5) Gupta appears like a Barbie automaton in fashionable battle fatigues to create a destabilizing, fetishized doll – the domestic woman, or the soldier in combat. Responding to orders to "shop, pray, order, talk" (you could add "love, smile, fornicate"),

she mimics the orders of patriarchy, the market and militarism. When the procedures of everyday life are repeated, an unconscious mathematical rhythm is brought about that structures space, time and, most pertinently, emotions.[16]

The machismo and glory of performative conflict (as in Gupta) raise the moral question of violence as entertainment and spectacle. In Manish Swarup, two areas of conflict recur. They include the communal conflagration in the state of Gujarat in 2002–3, and the simulated conflict of the wrestler, of sport for pleasure, in the Hanuman Akhada, Delhi's oldest wrestling rink. The writers Lentricchia and McAuliffe, in their post-9/11 work, explore the disturbing synergy between creativity and violence. In another study, writer and critic Simon Caterson draws a parallel between the "shock and awe" invoked by U.S. President George Bush in the bombing of Iraq, and the "shock of the new" in art and terror as an apotheosis of spectacle.[17] In its transmission from the site of violence to the image in the art gallery, the violent act becomes aestheticized and performative.

The passage from the private to the public, and then again to the realm of private fantasy, feeds into

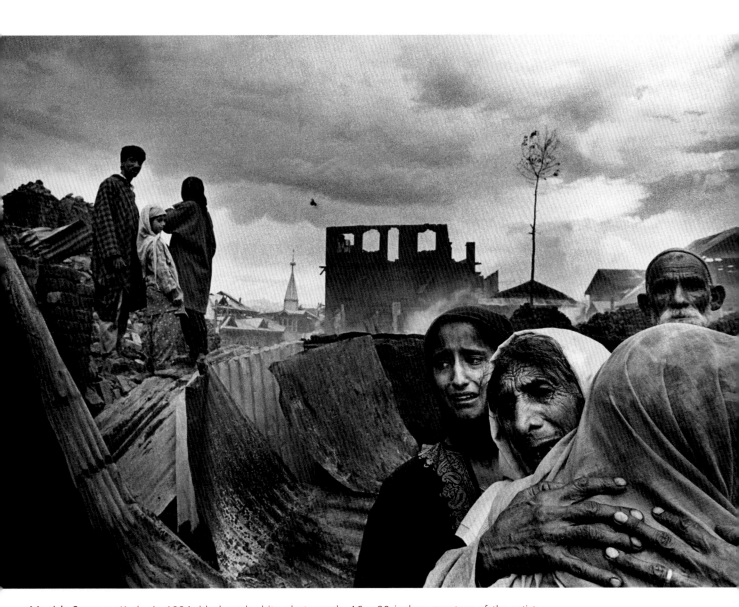

Manish Swarup, *Kashmir*, 1994, black and white photograph, 16 x 20 inches, courtesy of the artist

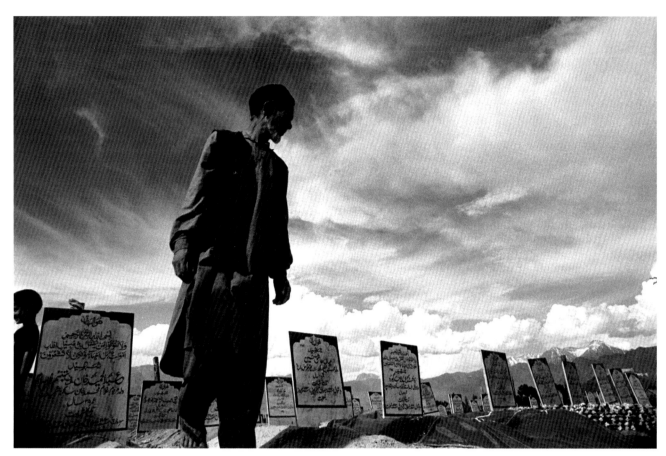

Manish Swarup, *Kashmir*, 1994, black and white photograph, 16 x 20 inches, courtesy of the artist

Rajesh Vora, *Beauty Pageant*, *Mumbai*, 1997, black and white inkjet print, 11 x 14 inches, courtesy of the artist

India's uniquely transgressive entertainment industry. Rajesh Vora and Shahid Datawala render aspiring beauty queens and Bollywood devoid of color. They look instead at the small indignities away from the arc lights, or tired bodies behind the scenes – sites of aspiration and certain failure. Datawala's work on Bollywood locates cinema as chimera. A subtle interrelationship is established between the exhausted pleasure of the old cinema hall, and the flotsam of the street, and the energy of Bombay's dream factory.

Inevitably public sites, spaces where an administrative order of law operates, also are vested with a moral quotient, and one in which the documentary becomes the voice of the public conscience. Ravi Agarwal works with the idea of abandonment of people and places in an aggressive urbanism. In step with his work on urban ecology, he brings attention to bear on the contamination of the

river Yamuna, historically consecrated as a holy river and envisioned in Indian poetry and religious thought as the site for the sport of the divine Krishna. As the Yamuna flows through modern Delhi, bearing the effluents and the detritus of the city, its mythos is blunted by indifference. Like a forgotten beloved, the Yamuna in Agarwal's images reflects abandonment and neglect. Some of the same spirit permeates his earlier photographs of migrant street labor in Gujarat.[18]

The overspill of the public into the private, the political into the personal, is imaged in the series of portraits by Vivek Vilasini. Traveling through the state of Kerala, Vilasini encountered people named Marx, Lenin, Che Guevara, Soviet Breeze, Ho Chi Minh, Gramsci and Stalin, all living within a radius of five kilometers. Vilasini speaks critically of the penetrative influence of politics, even long after the political equation has changed in the former Soviet Union and Eastern Europe. He writes, "The day I went to photograph Gorbachev he had gone early to work in the paddy fields and Mao Tse Tung had a fight with the local party bosses and refused to be photographed...."[19]

The slippage between the rural and the urban, now linked by technology, is seen in Samar and Vijay Jodha's work. Their photo documentary, *Through the Looking Glass: Television & Popular Culture in South Asia*, allows the television set to function as the ubiquitous eye as it penetrates a number of Indian

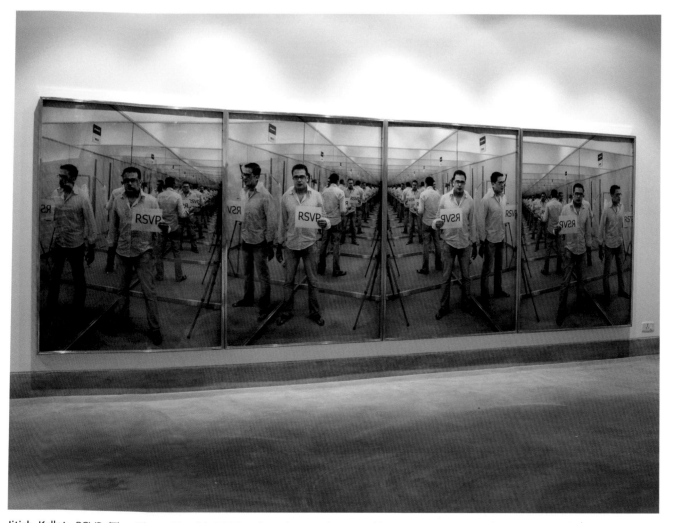

Jitish Kallat, *RSVP (The Closet March)*, 2005, color print on photographic paper, 64 x 192 inches, courtesy of the artist

interiors. Since its introduction in 1959, television in India has become a social leveler, blurring lines of taste and class. In many instances, it is an Indian family's first brush with modernity and the world. By abstracting the occupants of each space, the television in the Jodha work also functions as a voyeur, revealing the interiors of homes caught unawares.

Situating his own body in the public space allows the artist to enact and play out contradictory impulses. Jitish Kallat plays the common man in his photographs to interrogate a post-1990s globalizing India and its staccato energies. In the large photographic work titled *RSVP (The Closet March)*, he is reflected innumerable times in the mirror of a trial room in a shopping mall, which is symptomatic of the new Indian economy and a sudden moment of crisis in identity. Kallat plays the incidental witness again in *Artist Making Local Call,* in which the phone booth serves as the private space in the public area. Much of Kallat's recent work evokes the city as "Rickshawpolis," the site of violent encounters between generations of technology, First and Third World economies, as they meet head on in the street.

ROUTES OF DIASPORA

Since the 1990s, the Non Resident Indian (NRI) has functioned on the global routes of diaspora. The NRI has mediated between home and the world, rooted in a nostalgia for India, but only partially comfortable with her present. In this India of flux, the diaspora returns with an increasing force. Sunil Gupta's early photographs of Delhi locate the ambiguous nature of gay contact against the backdrop of the Lodi tombs, or public gardens. From his movement between Canada, England and India, two bodies of work emerged: *Exiles* and *Homelands.* Here, he locates his own gay HIV-positive body against the politics of postcolonial diasporic identity, and uses the diptych to transpose signifiers of Indianness in his location in the West.[20] Back in India, he returns to photograph Mundia Pamar, his ancestral village in north India. He also affirms his own sexual identity in the homeland through poetry and metaphor.

The aspiration of the immigrant held in tenuous balance against the memory of the homeland is petrified in the work of Gauri Gill. Gill, a Stanford University alumnus in photography, observed Indian families on the West Coast of the U.S. with the marks of Indianness and the new diaspora identity that they bear. Here, labor and migrancy become symptomatic of modern India and its energetic engagement with globalism, but one that starts at the village with its immediate concerns of food and survival. In many ways, the immigrant's journey across continents mimics the millions of journeys that have occurred across the map of India, creating new untold narratives.

When photographing Indians in America, the photographer tends to assume the view from afar or

Gauri Gill, *Bikaner, Rajasthan* from the series *Urban Landscapes*, 2003, silver gelatin print, 10 x 15 inches, courtesy of the artist

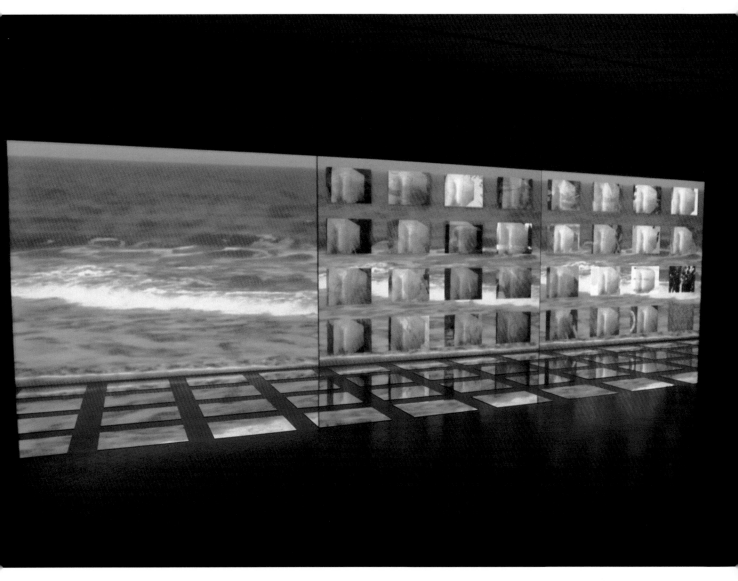

Navjot Altaf, *Lacuna in Testimony*, 2003, three-channel video installation with 72 mirrors, time variable, courtesy of the artist

the view from within. Pablo Bartholomew's images of middle class Indians demonstrate the movement away from an old culture to the visible accretions of the new. In the process, he creates a sense of both familiarity and loss. Annu Matthew, who lives and works in the U.S., takes on the view of transnational anthropology to create diptychs of certain imbalance between culture and power, tradition and modernity, local and global. Matthew suggests, through a performative creation of stereotypes, that there is no master narrative of the modern and that the visible disjuncture between self and the other is embedded in the loaded and contentious views of "civil" society. In this way, she creates an anthology of pathways, seeking to locate and dignify ethnicity in an increasingly flattened world.

The shifting view of the photographer on different continents has a continuing coherence in the work of Raghubir Singh. Singh's India validates and affirms the street energies of subaltern figures with which he fills his frame. His work, in full chroma, creates an epistemology of democratic spaces, of what he called "the democratic eye," or one in which the condition of the street can be heroic or banal, but always vital.

An unconscious heaving tableau, where the incidental face becomes a portrait, the unconscious gesture determining the rhythm of the tableau. This is in sharp contrast to Navjot Altaf's engagement with the public space as a partisan site in history. Shot from the edge of the Arabian Sea marking the ebb and flow of water, *Lacuna in Testimony* depicts the blurring of line and space in the continuous act of erasure. Navjot speaks of contemporary history in a language of poetic abstraction. The close view of the Arabian Sea brings to mind the concept of *pralaya* or great flood of the Indian mythic imagination. *Lacuna in Testimony* came in the immediate aftermath of communal rioting in Gujarat, in 2002, which was one of the worst demonstrations of the collapse of common law in modern India. The plaintive cry of the child that runs through the work speaks of the inadequacy of the law, where testimony cannot be rendered. Where the sea gives up its sanguine bloody tones to return to normalcy, we return to the idea of the waters as healing and elementally vital.[21]

PRIVATE SPACES – BODY AS CONTEXT

Indians have instinctively understood the power of photography to create the iconic, the play of spectacle and masquerade. From their early inception, photo studios proliferated from Bengal to the North-West Frontier Provinces and were patronized by people from every class. Almost in willful subversion of the gaze of imperial painters and photographers, who classified Indians according to caste and tribe (see for instance the eight-volume *The People of India 1868–1875*),[22] the Indian as photographer and subject appears to have run the entire gamut from performance to masquerade. Photo studios provided clothes, backdrop and props, and "artistic" over-painting of the photograph, which allowed the subject to collaborate in the creation of an assumed location, mood and social identity.[23]

In the 1930s and 1940s, photographs of nationalist leaders found a new locus in an ideal imaginary. Not uncommonly, a "national" identity was created in popular prints and paintings through locating divinities like Krishna or Mother India within the national struggle. This was achieved through a collage of photographic cut-outs within a mythic / idealized space. The introduction of the photograph created a sense of the real, and the idealized landscape conjured up a benign vision of India free from British rule.[24] Against this legacy of a manipulated "realism," the contemporary photographer feels free to engage with critical social questions to problematize issues of gender, political and social identity.

GAZE / *DARSHAN*

There are at least half a dozen words in the Indian languages of Hindi and Urdu that approximate the word "gaze." One is *darshan*, or the act of seeing and being seen. This has particular valence in the contexts of photography, and by extension, cinema. *Darshan* translates roughly as the exchange of the gaze usually between a deity as icon and the devotee.[25] Commonly, photographs of the deceased in India may be garlanded, marked with a *tilak* and offered incense, thereby gaining active agency as votive objects. Thus, the uses of photography in India sharply rebut literary critic and philosopher Walter Benjamin's position that "Even the most perfect reproduction of a work of art is lacking in one element: its presence in time and space, its unique existence at the place where it happens to be."[26] The photographic portrait in India, like the popular oleograph of the early nineteenth century, became particular by embellishments of paint, or decorative "dressing." Like the early studio portrait, which offered the sitter the option of magical transformation, the contemporary artist's portrait is far from straightforward. The mechanism of collaborating in one's own image, to mutate the limits of the self and flirt with a body that can enter other times, histories and bodies, proves irresistible.

Photographers Raghu Rai, T.S. Nagarajan and Dayanita Singh[27] have worked with the family portrait to establish the important components of interiority and class. While an area of compelling interest, the homes of the poor, the rich and the middle class have

Unknown photographer, *Hand-painted Photograph Decorated with Lace Mount*, Central India, c. 1920s, collection of Gayatri Sinha

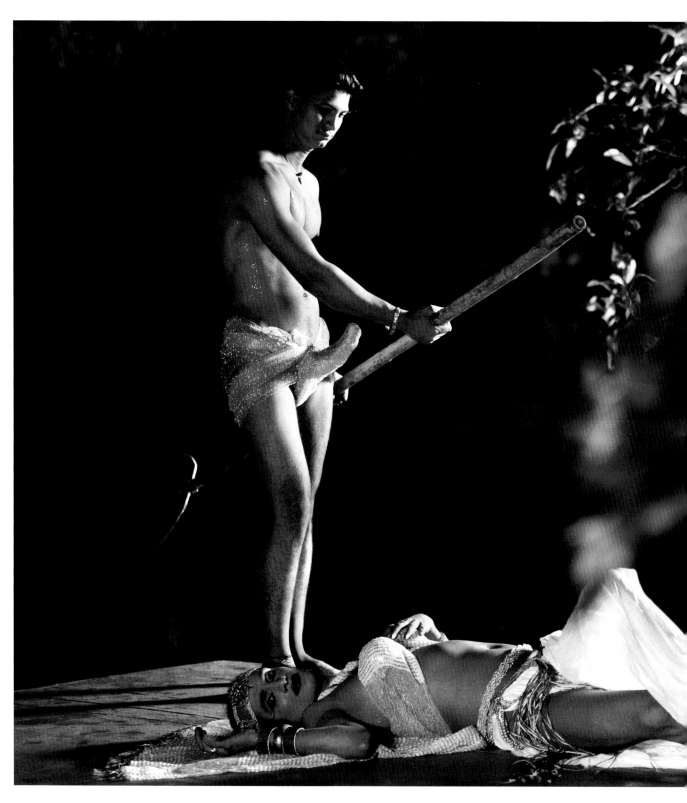

Tejal Shah, *The Barge She Sat in, Like a Burnished Throne / Burned on the Water*, 2006, digital photograph on archival photo paper, 38 x 57⅞ inches, courtesy of Thomas Erben Gallery, New York & Galerie Mirchandani + Steinruecke, Mumbai, collection of the artist

been largely ignored by the world press. Nevertheless, the Indian body in familial or domestic relationships, bearing coda of class and sexuality, suggests numerous possibilities for representation.

THE PERFORMATIVE SELF

Pushpamala N. revives the sepia tint studio portrait, ethnographic colonial representations, classical Sanskrit definitions of the "ideal heroine" and Bollywood-style images, to interrogate the representation of women in India. "I do think of my audience as primarily Indian or sub-continental, who would understand the background and nuances," she writes.[28] In the photoromance *Phantom Lady or Kismet,* she plays both the masked heroine and the gangster's moll, mimicking the stunt movie fantasy of 1950s Bollywood. Pushpamala's training as a sculptor enables her to successfully set up a tableau within a mise-en-scène, with an emphasis on plastic values.

The staging of the mise-en-scène may appear to mimic high art, but the intention is frequently camp. *The Navarasa Suite* uses both theatre and artistic intervention to draw upon tropes of femininity. By inscribing that style on the heroic / self in nine leading emotional states, Pushpamala references typologies of emotion and desire, fixed in public memory through Bollywood.

Erotic desire as a subject in photography can be powerfully transgressive. Tejal Shah and Sunil Gupta queer the gaze, but through different strategies. Shah mocks at the tropes of heterosexual love fantasies as envisioned in cinema and popular aesthetics to present desire outside the bounds of compulsory heterosexuality. Indian cinema, traditional theatre and dance have a rich tradition in cross-dressing, with men performing the roles of women in the public sphere. Shah, who has set herself up as a critical spokesperson for the enactment of alternative sexualities, traverses the terrain of sexual difference and the transgendered gaze. In her video work *Trans-,* the artist's mocking scene of making up before the mirror draws on expectations of difference that is male–female, white–Asian, straight–gay.

◀ **Sunil Gupta**, *Untitled* from the series *Looking for Langston – A Film by Isaac Julien*, 1989, silver gelatin print, 23 x 15 inches, printed 2007, courtesy of the artist

▼ **Sunil Gupta**, *Untitled* from the series *Looking for Langston – A Film by Isaac Julien*, 1989, silver gelatin print, 15 x 23 inches, printed 2007, courtesy of the artist

Like Shah, Subodh Gupta projects erotic desire on his own body. His life-size photograph, *Vilas*, reveals the artist's body as a site for pleasure and one that invites the participatory pleasure of the voyeur.

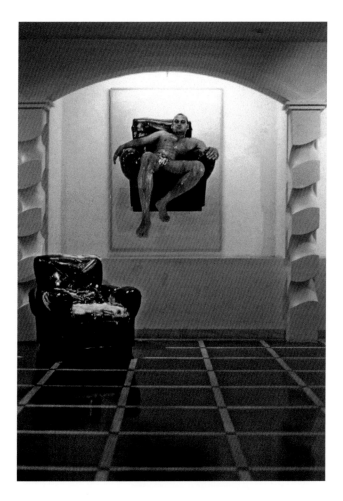

Subodh Gupta, *Vilas*, 1999, photo installation with c-print, sofa-chair (rexine, foam, wood), petroleum jelly, photograph 71 x 51 inches, sofa-chair 31½ x 31½ x 33 inches, courtesy of the artist

In the video work *Pure*, Subodh Gupta foregrounds the nude performative body as it is increasingly covered with cow dung in the shower. Gupta, originally from Bihar, engages directly with cow-belt politics of north India, conspicuously the fodder scam of Bihar politics of the mid-1990s in which cattle fodder was imported into India. The cow, venerated by millions of Hindus, is deified by Gandhi as a symbol of purity. Gandhi had said, "The cow to me means the whole sub-human world and again by every act of cruelty to our cattle we disown God and Hinduism."[29] In Hindu mythology, the cow is venerated in association with Krishna and as Kamadhenu, or one who fulfills the wishes of her devotees. Cow dung, used as a symbol of purity in Hindu rituals and as fuel, is central to the economies of the Indian village, where 70 percent of India still lives. By "polluting" himself with dung, Gupta brings us up short on the displacement of Gandhian values in contemporary India and the perceptual cultural view between purity and defilement.

The notion of the public and the private, along with purity and defilement, creates other sites of tension. The river Yamuna as a holy site receives ritual offerings of flowers, lights and ashes of the dead. Atul Bhalla, as he immerses his body in the waters, recalls the Hindu act of immersion in the holy river, but also implicates the act of ritual suicide. If in Ravi Agarwal the river is like an estranged beloved, Bhalla creates an osmosis of associative meanings in which body fluids such as the river become sites of necessity, pleasure and contamination.[30]

OTHER HISTORIES

Contemporary photography in India is determined by the geopolitics of the region. Equally, it is sustained by the synergy with art, with international residencies, biennales and curatorial interventions. There also is the visible desire of the artist / photographer to work against predicated (art) histories, to dismantle myth and create alternative identities. In the wake of violent conflict in Iraq, Afghanistan and Kashmir, Indian artists have responded to the militarization of the geographical arc that extends from West to South and Southeast Asia, thus initiating a re-mapping of active political concern. Like Shilpa Gupta, Anita Dube uses camouflage material not on the body, but to cover objects of usage, such as in a vault to signify the coherence between money and gun culture. In the work *Kissa-e-Noor Mohammed (Garam Hawa)*, she slips into gender ambiguity to assume the persona of

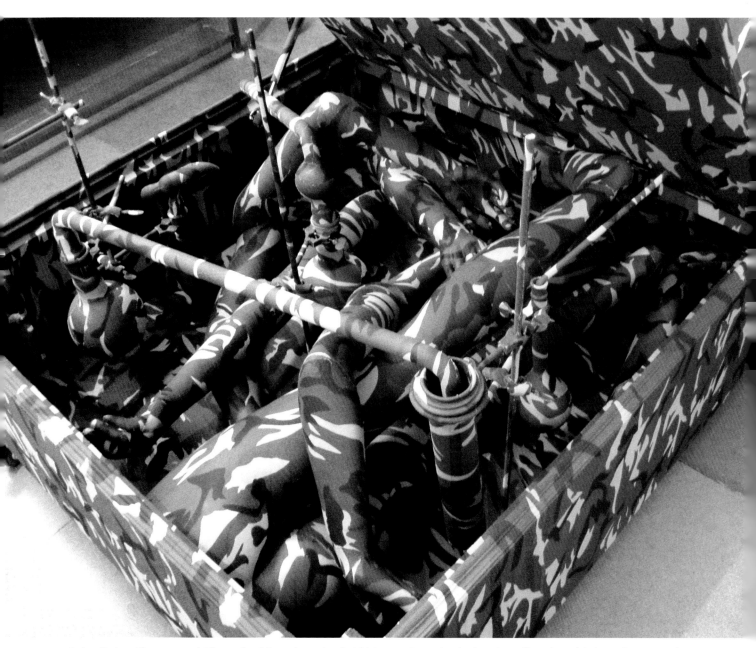

Anita Dube, *Phantoms of Liberty (bed / surplus values)*, 2006, wood, steel, plastic, glass, fiberglass, fabric and mannequin parts, dimensions variable, courtesy of the artist

Noor, an artisan who works with Anita Dube, the artist. Dube, who grew up in Lucknow and trained in art criticism at M.S. University of Baroda, uses the device of the interlocutor to set up a dialogic exchange between people and events, materials and ideas. In this monologue, Noor represents the sexual minority as well as the poor Muslim male who speaks of the gradually eroding social fabric and of desire and loss in a fraught period of contemporary Indian history.

In the consideration of the objective / subjective space, women as artists rework existing structures of power and dominance. Sonia Khurana, in the work *Head-Hand*, deploys a political / aesthetic strategy founded on terms of difference.[31] Colonial and postcolonial issues, both male and female and active and passive, are evoked in this vision of uncertain pleasure and suggestive domination. While other artists in the show, such as Pushpamala N. and Shilpa Gupta invite the gaze, Khurana in both *Tantra* and *Head-Hand* uses a circuitous, suggestive strategy for the metaphors of the body. Sexuality and power find another reading in Surekha, who draws on the perception of infertility to expand on issues of ecology. Her video *Tree Woman* invites reference to an ancient Indian myth described by the commentator Mallinatha in the 9th century. In this fertility belief, a woman could touch a tree and cause it to burst into bloom. Surekha turns this belief around, with an apparently barren woman bringing an entire grove into existence, thus extending her critique to the equation between femininity, youth and the reproductive body.

PURSUIT OF DREAMS

Does photography enter an unplanned curve in which it withdraws from the expository and the real into the fabular and the unreal? It may be difficult to map the precise point at which this happens, but the intersection of culture, history and art has led to a new expressivity. Possibly the most vivid example of this phenomenon is the series of exhibitions titled *Re-take of Amrita,* which draws on images of Amrita Sher-Gil, an early modernist. Made by Sher-Gil's nephew Vivan Sundaram, the body of photographs sets into motion a chain of inter-ocular relations between medium, historical frames and artistic intentionality as it traverses continents, and an intertwined family narrative. "I see seduction as central to these images. The digital tool allows me to invoke the state of immanence so passionately imaged by Umrao Singh in his self-portraits and equally in his portraits of his daughter, Amrita. Here is a seemingly real, entirely constructed drama of self appointed egos."[32] In Sundaram's recent version of *Re-take of Amrita* (published 2006) the assemblages and tableaux of figures are essentially performative. The still posed aspect of Sher-Gil's paintings and Umrao Singh's photographs of his family reflect on the assumption of numerous identities and locations. Here, the digital medium allows Sundaram to do what other mediums do not: to shuffle, rearrange and vivify a "fixed" family archive into a number of vital narratives.

The apparent contradiction of implicating the evanescent in the material, the performative in a dream state, comes together in the work of Ranbir Kaleka. Kaleka, essentially a fabular painter in whom reverie and social signifiers come together, uses performance to blur the image from the imaginary, and the real from the fictive. Questions and evocations around desire and loss appear with a repetitive insistence. The essence of *Cockerel-2* is cyclic repetition of gesture, a seemingly banal act that exists without a narrative. The act of possessing the cockerel and then losing it becomes a metaphor for pursuit and loss, and by extension, of the processes of life itself. In such works, in the movement from the personal to the philosophic, photography and video reach a level of expansion and metaphysical engagement.

From a conservative medium of representation, photography and video practice in India now serves as an index of societal change. In the last two decades, which is the period broadly covered by this exhibition, India seems to be witnessing a reverse aging process. A traditional, classical culture has morphed into a new "soft" technological power. The colonial elite have made way for the energetic onrush of the "backward" castes, and the oral narrative of mythology has slipped

easily into the visual literacy of the media image. The repositioned medium works to meld idea with image, with the artist using his or her own body as a site for distillation and dissent. Seen outside sites of mass spectatorship, the lens-based work abandons the quest for verisimilitude, and assumes the possibility of catharsis and play. The lens allows the pursuit of a dream.

NOTES

[1] The influence of British painting on photography was marked. "Between 1782 and 1809, Dr William Gilpin published a series of small guides relating to the production of 'picturesque' scenes. Transported to India, his canons were often applied to photography." Clark Worswick and Ainslee Embree, *The Last Empire: Photography in British India, 1855–1914* (Millerton, New York: Aperture Foundation, 2001), p. 2.

[2] C.A. Bayly, ed., *A Shifting Focus: Photography in India, 1850–1900* (London: The British Council, 1990).

[3] For a vigorous critique of Third World representation in the world press see Okwui Enwezor, *Snap Judgements: New Positions in Contemporary African Photography* (New York and Göttingen, Germany: International Centre of Photography and Steidl, 2006).

[4] Gayatri Sinha, *Middleage Spread: Imaging India, 1947–2004* (New Delhi: Anant, 2004).

[5] Jyotindra Jain, in *Indian Popular Culture: The Conquest of the World as Picture,* exhibition catalogue (New Delhi: NGMA, 2004), p. 27 records that in the 1860s there were more than 300 commercial photographers in Calcutta alone.

[6] See R.C. Majumdar, *British Paramountcy and Indian Renaissance* (Bharatiya Vidya Bhavan, Bombay, 1991, Vol. II, Chapter 6, "The Press," pp. 240–3).

[7] "Further Reflections on the Public Sphere," in Craig Calhoun, ed., *Habermas and the Public Sphere,* trans. Thomas Burger (Cambridge: MIT Press, 1992).

[8] Cartier-Bresson, who had spoken of the camera as a sketchbook and an instrument of intuition, was the master of "the decisive moment," an influential element in street photography. He said "you'll observe that if the shutter was released you have instinctively fixed a geometric pattern without which the photograph would be both formless and lifeless". Quoted in Vicki Goldberg, ed., *Photography in Print* (Albuquerque: University of New Mexico Press, 1988), p. 385.

[9] Yves Véquaud, *Henri Cartier-Bresson in India* (Paris: Centre National de la Photographie, 1985; London: Thames and Hudson, 1997).

[10] Sabeena Gadihoke, *India in Focus: Camera Chronicles of Homai Vyarawalla* (New Delhi / Ahmedabad: Parzor / Mapin 2006). Vyarawalla was Prime Minister Nehru's favorite photographer, and she speaks of the ease with which he engaged with the camera.

[11] Kishor Parekh, *Bangladesh – a brutal birth,* 1971, an exhibition of photographs taken during the first few weeks of the Bangladesh war.

[12] Raghu Rai, *Indira Gandhi: A living legacy* (New Delhi: Timeless Books, 2004).

[13] Shakti is the feminine embodiment of all power, an abstract principle. "The sound 's' means welfare or prosperity and the 'kti' prowess." Quoted from Vettam Mani, *Puranic Encyclopaedia* (Delhi: Motilal Banarsidass, 1993), p. 668.

[14] See catalogue *Ram Rahman Photographs* (Chennai: Apparao Galleries, 2006).

[15] Leading Indian documentary filmmakers Anand Patwardhan, Amar Kanwar and Madhushree Dutta offer different degrees of critique and subjective engagement in their work.

[16] Nancy Adajania, catalog essay "Addressing that Unknown Quantity in Indian Art: The Viewer," in *Shilpa Gupta* (New York: Bose Pacia 2006).

[17] Frank Lentricchia and Jody McAuliffe, *Crimes of Art and Terror* (Chicago: University of Chicago Press, 2003); Simon Caterson, "The Art of Terror", *The Age,* October 15, 2005.

[18] Jan Bremen and Veena Das, *Down and Out: Labouring Under Global Capitalism* (New Delhi: Oxford University Press, 2000).

[19] Quoted from a letter by Vivek Vilasini to the writer, dated December 15, 2006, in Gayatri Sinha, "A Life Away from Life," *The Hindu,* October 28, 2005.

[20] Sunil Gupta, *Pictures from Here* (London: Chris Boot Ltd., 2003).

[21] Nancy Adajania, see catalogue, *Navjot, Scaffoldings of Survival: Reflections on a Life of Projects* (Mumbai: Sakshi Gallery, 2004).

[22] John Forbes Watson and John William Kaye, eds., *The People of India: A Series of Photographic Illustrations with*

Descriptive Letterpress of the Races and Tribes of Hindustan, Originally Prepared Under the Authority of the Government of India, and Reproduced by Order of the Secretary of State of India in Council, 8 vols. (London: India Museum; W.H. Allen, 1868–75).

[23] See Nishtha Jain's documentary film on the small street studios of India, *City of Photos* (2005.) It draws on street-side studios that use popular backdrops including those of the burning twin towers.

[24] See Jyotindra Jain's illuminating essay on the morphing of corporeal photographic reality within a mythical space in *Indian Popular Culture: The Conquest of the World as Picture*, exhibition catalogue (New Delhi: NGMA, 2004).

[25] Christopher Pinney, *Photos of the Gods: The Printed Image and Political Struggle in India* (London: Reaktion Books, 2004).

[26] Walter Benjamin, "The Work of Art in the Age of Mechanical Reproduction," 1935. Reproduced in Walter Benjamin, *Illuminations: Essays and Reflections* (New York: Schocken Books Inc., 1969), p. 219.

[27] Dayanita Singh, *Privacy* (Göttingen, Germany: Steidl, 2003).

[28] *Pushpamala N: Indian Lady* (New York: Bose Pacia, 2004).

[29] M.K. Gandhi, *The Essence of Hinduism* (Ahmedabad: Navjivan Publishing House, 2002), p. 33.

[30] *Self x Social*, curated by Geeta Kapur, School of Arts and Aesthetics, Jawaharlal Nehru University, New Delhi, 2005.

[31] Lisa Tickner, "Sexuality and / in Representation: Five British Artists" (1985), in Hilary Robinson, ed., *Feminism – Art – Theory* (Oxford: Blackwell, 2001).

[32] *Vivan Sundaram: Re-take of Amrita* (New York: Sepia International and the Alkazi Collection, 2006). The digital photo-montage images draw on the photographs of Vivan's grandfather Umrao Singh Sher-Gil (1870–1954) and his archive of 600 photographs, and the paintings of Amrita Sher-Gil (1913–41).

Clouding the Mirror

Trends in Recent Indian Photography and Video

PAUL STERNBERGER

The colorful vibrancy of the Indian physical and social landscape makes it relatively easy to take stunning photographs of the country, but it also breeds common visual and cultural clichés. Images of dynamic public rituals, robed holy men and pilgrims, picturesque villagers, teeming city streets, and prostitutes and beggars dominate touristic collections of photographs in popular books and magazines about the country. These clichés shape much of the West's photographic understanding and expectations of India and exotify and marginalize Indian subjects. This is especially true when audiences accept photography as a truthful, unmediated record of the world and a surrogate for real experience.

Photographers in this exhibition tend to subvert these expectations. Sometimes this subversion comes through calculated control of photography as a documentary and narrative medium. More frequently, it comes because the photographers insist on an understanding of photography as a tool in the hands of an individual with a particular agenda, be it social and political activism, reasoned cultural analysis or poetic self-expression.[1] Reflecting international trends in which the photographers stress their role as image-makers rather than image-takers, Indian photographers in the last quarter century have found increasingly self-conscious subjective modes with which to engage the Indian and global social landscape. Building upon a strong tradition of photojournalism and street photography, Indian photographers and video artists have embraced photography as an expressive performative tool capable of facilitating a range of artistic endeavor and social engagement.

Through a variety of strategies ranging from photojournalistic reportage to poetically elusive narratives, artists in this exhibition reveal many contentious layers of meaning in their images. They exploit the tension between an objective reality of the world that is recorded and their use of photography and video as tools of self-conscious subjective expression. The opposition of the analytic and the subjective in these artists' responses to contemporary experience mirrors the role that public and private forces play in shaping their work. They explore the complexities of shared cultural experience in India and how it both eclipses and defines the intricacies of individual identity. Many of these artists reveal an underlying anxiety, drifting just beneath the surface of India's façade of national and cultural coherence. Despite the constancy and order suggested by an increasing global economic and technological presence, that veneer can be quickly punctuated by social and political turmoil, which highlights the complexity of India's cultural amalgam. This anxiety invites many interpretive avenues and manifests itself in many ways, from the socially engaged photo essays of Ravi Agarwal, to Pushpamala N.'s sardonic performances before the camera, to Ranbir Kaleka's quiet ruminations on human experience.

THE SUBJECTIVE WITNESS

India has a strong tradition of lyrical street photography and discerning photojournalism. Henri Cartier-Bresson, arguably the most influential figure in twentieth-century street photography and photojournalism, made a large body of work in India and photographed there soon after its Independence, and in the 1950s and 1960s.[2] Whimsical, witty and observant, Cartier-Bresson helped define the street photographer as an insightful witness, capturing the "decisive moment" that a good picture presents.

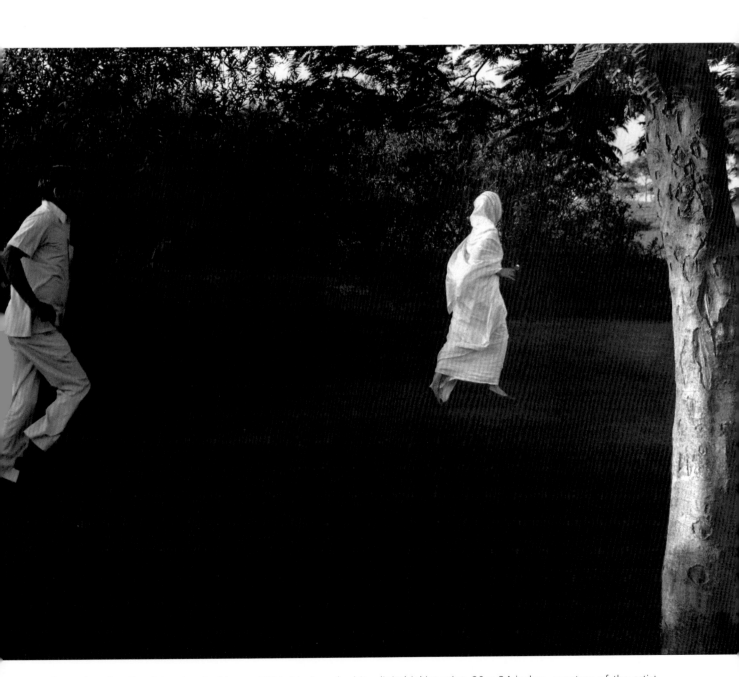

Raghu Rai, *Indira Gandhi at her Residence*, 1984, black and white digital inkjet print, 20 x 24 inches, courtesy of the artist

Often, early street photography and photojournalism presented a heartfelt affirmation of the human experience, an aesthetic embraced by *Life* magazine and institutionalized by The Museum of Modern Art's 1955 *Family of Man* exhibition. S. Paul and Raghu Rai are among a remarkably talented generation of groundbreaking photojournalists who brought the affirmative humanism and insightful eye of street photography to the record of a young India. They capture both the momentous and the poetically banal, focusing their cameras on both major historical events and casual everyday life in India. Rai's photographs of Indira Gandhi rushing phantom-like through her gardens ahead of her aide, and of anguished crowds mourning her assassination humanize personalities and historical events that would alter the trajectory of India's history in the late twentieth century.

An understanding of photography as bearing witness to the world, or as a mirror that can reflect the seductive and colorfully complex social landscape of India, continues to energize a tradition of Indian photojournalistic photography. In the hands of photographers such as Manish Swarup, Pablo Bartholomew and Ravi Agarwal, the camera continues to offer glimpses into the Indian cultural fabric. It creates not simply documents of the social landscape or witnesses to historical events, but also focused cultural commentary and analysis. Swarup constructs photojournalistic narratives about subjects as wide-ranging as enclaves of wrestling devotees and the aftermath of vicious religious rioting in Gujarat. He guides his viewer to an understanding of the tender comradeship of young men pursuing traditional training for the once royal, but now disappearing,

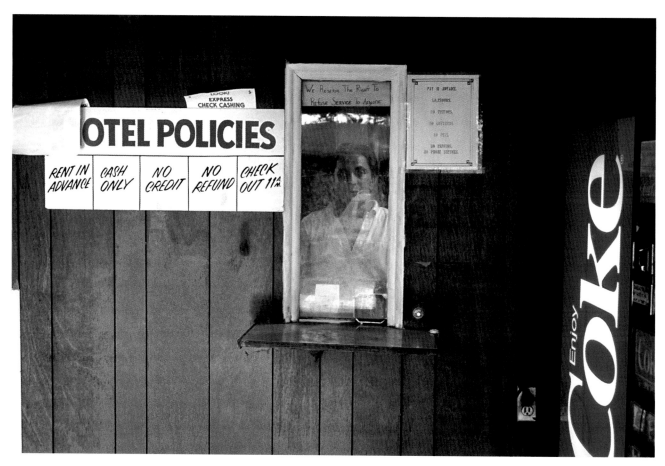

Pablo Bartholomew, *One of the Many Patel Motels, Fresno*, 1987, from the series *Emigrés*, color photograph, 11 x 14 inches, courtesy of the artist

sport of wrestling. And Swarup's image of Gujarati boys, who appear at once innocent and also world-weary, focuses not on the spectacle of physical violence, but rather on the subtler, yet no less devastating, human impact of the horrific events of 2002. Pablo Bartholomew, one of India's finest photojournalists and mentor to many young photographers, has made iconic images of the human impact of historical events, including the horrific 1984 Union Carbide gas leak in Bhopal. But he has turned his camera toward subtler cultural phenomena as well, photographing Indians living abroad as they balance their cultural heritage with the traditions of their new homelands. Bartholomew's frank visual descriptions of Indians, in the environments that define them within the American landscape, investigate a spectrum of the Indian diasporic experience in America, from the lobbies of seedy motels to cutting-edge technology laboratories.

Raghubir Singh, *Pedestrians, Firozabad, Uttar Pradesh*, 1992, 36 x 60 inches, © Succession Raghubir Singh

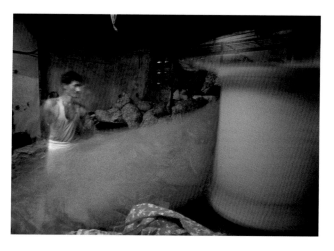

Ravi Agarwal, *Printing of Cloth, Surat, Gujarat*, 1997, from the series *Down and Out: Migrant Labor in Gujarat*, 11 x 16 inches, courtesy of the artist

For Ravi Agarwal, photojournalism becomes a tool of social activism and more as he delves deeply into the lives of laborers in southern Gujarat, whom he calls "some of the most politically and economically marginalized people," or into the shifting relationship between the city of Delhi and the river Yamuna. And as Gayatri Sinha points out in her essay in this catalog, the historical and religious significance of the Yamuna makes it an appropriate springboard for Agarwal's personal and spiritual associations. Many of Agarwal's images present more than just visual narratives about the lives of his subjects – they have an inescapably photographic quality that makes the viewer aware of the process of picture-making. In his photograph of a Gujarati textile dyeing and printing mill, spinning bolts of cloth and the dynamic gestures of a worker move more rapidly than the camera's shutter, creating a partially blurred image that makes it clear the viewer is encountering a photographic interpretation, not the scene itself. For Agarwal, these photographic explorations lead to personal and philosophical insights. In his exploration of labor, for instance, he writes, "I came to understand and see an assertion of life itself, which played out within the interstices of human politics and human survival."[3]

Photography's ability to be a means of self-revelation like Agarwal's has helped inspire the development of a self-consciousness and deliberateness in the picture-making process. This is a feature that has become more and more an

acknowledged characteristic in contemporary photography in India. Raghubir Singh, probably India's most internationally recognized photographer, recalled that his early influences where not only street photographers such as Cartier-Bresson, André Kertész and Robert Frank, but also photographers with a knack for carefully composed compositional structures such as Eugène Atget and Walker Evans. Building on what he himself described as "the old *Life* magazine kind of photography," Singh developed a style that revealed his own "visual and emotional relationship to India," which was both intuitive and self-consciously pictorial.[4] An incredibly keen observer of the Indian public sphere, Singh explores many subtle aspects of contemporary India. These include the intersection of the public, the private, the political, the commercial and the religious in the Indian landscape. But Singh reaches far beyond the subject matter of the street and presents the artist as a maker of

intensely multilayered images, both visually and conceptually. In *Pedestrians, Firozabad, Uttar Pradesh*, Singh generates a pictorial complexity with the simultaneous transparency and reflectivity of a car window, which integrates different zones of pictorial space into a single plane. The stark forms of the car door eclipse parts of the scene, while, at the same time, the door connects the viewer's space to the streetscape. The multitude of gazes, including those directly confronting the camera, creates powerful psychological tensions between the subjects themselves, but also with the viewer. In a spectacular body of color work that exploits this pictorial complexity and active engagement of the viewer, Singh helps create a bridge between the photojournalistic aspects of street photography and a more conceptualized and subjective contemporary art photography.

A younger generation of photographers acknowledges an even more subjective critical and political engagement with their subjects. This sort of engagement can be found in the wry wit of Ram Rahman, who, like his friend and mentor Raghubir Singh, combines an eye for clever formal photographic structure with intriguing happened-upon street subjects. Until recently, Rahman spent about half his time in New York. This dual residency gave him some separation from India and afforded him, as Chidananda Dasgupta put it, "a valuable balance of the subjective and the objective outlook" in which he is "sufficiently distanced from [India] to be impelled towards a rediscovery of it, and close enough to know what is real and what is mere exotica."[5] This critical distance allows Rahman to let more of his sense of humor, personal world, and political stance slip into photographs. His clever images often feature chance juxtapositions of ironically contrasting elements of Indian visual culture: playful hand-painted signs alongside slick political posters; giant figures of strongmen and prime ministers drawn back into the ordinary world of open-air urinals and public parks; the intellectual and cultural elite engaging in casual antics at parties. Photographs by Ketaki Sheth and

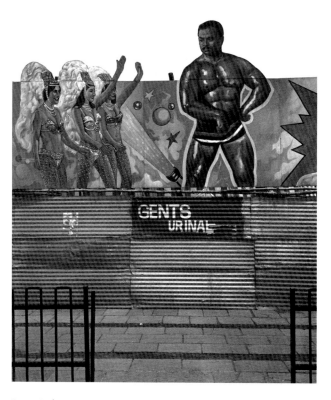

Ram Rahman, *Gents Urinal, Old Delhi*, 1991, gelatin silver print, 20 x 16 inches, courtesy of the artist

Ketaki Sheth, *Starlets in the Green Room, Bombay*, 1989, silver print, 14 x 20 inches, © Ketaki Sheth, courtesy of Sepia International

Rajesh Vora depicting movie stars and amateur beauty contests highlight the cult of celebrity that thrives as popular visual culture – especially cinema – seeps into contemporary experience in India.[6] With an eye for what she calls the "formal elements in photographs," Ketaki Sheth has explored the spectacle of Mumbai, including its "tinsel world of movies and private parties." With an interest in the juxtaposition of ordinary people with icons both of religious and of popular culture, her images underscore the presence of vast, shared experience of public space and personae that can coexist ambiguously within the private personal realm of the individual.[7] Television, print media and cinema permeate the complex federation of subcultures that constitute India as a nation. Individually, Indians' experiences can be as

diverse as their economic and social status – from low caste ragpicker to marginalized Muslim and middle class digerati to movie mogul. Yet, as consumers of this ever present mass media and entertainment, Indians share a common, media-driven, visual and cultural language.

A MORE CALCULATED CONCEPTUAL APPROACH

The intersection of the private realm of the individual and the spectacle of shared public experience has been explored by photographers working in a more conceptual documentary mode in which the seeming spontaneity of the street photographer is replaced by a more calculated, systematic approach. Vivek Vilasini's portraits of villagers in Kerala with names such as Lenin, Che Guevara and Soviet Breeze underscore the

Marxist leanings of the region. Samar Singh Jodha dedicates a great deal of energy to what he calls "social communication," both as a critical observer of contemporary visual culture and as an active participant in projects aimed at social change. His *Through the Looking Glass* project, a collaboration with his brother Vijay, takes the examination of television's impact on South Asian society beyond debates of the medium's scope of influence and explores it as an object in a physical setting that can offer insights into "changing values and lifestyles in diverse homes and workplaces, a change in which television is both a witness and an active participant."[8]

For Sheba Chhachhi, photography began as a tool for straightforward photojournalistic documentation

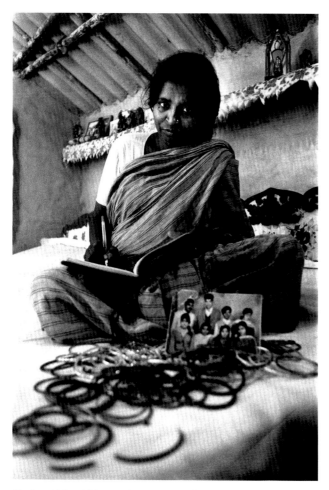

Sheba Chhachhi, *Devikripa*, 1990, from the series *Feminist Portraits: "7 Lives and a Dream"*, black and white photograph, 14 x 11 inches, courtesy of the artist

of women's movements in India. But as her photographic career evolved, Chhachhi began to shun the use of the photographic image as silent witness. Instead, she began not only to acknowledge her own activist stance, but also to facilitate the active participation of her subjects in the picture-making process. In these images, the apparent spontaneity of the street photograph gives way to posed portraits of women who work in collaboration with Chhachhi, engaging the camera and surrounding themselves with objects of self-definition.[9] Like Chhachhi, Dayanita Singh began her career with a photojournalistic eye and has steadily come to embrace subjectivity on both sides of the lens. Her portraits of upper class people in their homes escape the often clichéd chaos and poverty of the Indian streetscape and take the viewer into a private realm where the sitters' surroundings define their self-image as much as their expressions and demeanors. Singh is a master of visual poetics, and her more recent explorations of architectural interiors reveal expressive possibilities far beyond portraiture. The pensive quietude of her recent compilations of small prints in pocket-sized accordion books transcends the context of subject, culture or nation.[10]

Indian video artists, too, have made the shift from using the medium as a primarily documentary mode to a more subjective, expressive tool. A comparison of two works by Gigi Scaria illustrates these two modes. *A Day with Sohail and Mariyan* accompanies a pair of young ragpickers through their night-time rounds, introducing viewers to the boys' difficult and thankless tasks, while charming them with the boys' ability to retain some youthful playfulness. In contrast, Scaria's *The Lost City* presents a philosophical, fictional narrative. Here, the protagonist looks for ways to counter his rapidly disintegrating memory by creating a system of maps, texts and images that can remind him of his everyday routine. While *A Day with Sohail and Mariyan* offers insight into a real world of poverty and labor seldom seen by outsiders, *The Lost City* creates a world in and of itself – a contemplative inner world of personal and subjective experience.

SUBJECTIVE ANALYSIS

As Indian photographers and video artists have intensified their insistence on the understanding of their work as subjective interpretation and expression rather than as analytical records of the world, they have become more makers of images, rather than finders of them. These more obviously constructive artistic practices can be just as intense as a

citizenship, and homes in London and Delhi). "If here is in one's head," he writes, "then mine is in Delhi, as a kind of romantic ideal, with part of me in the familial safe haven of Canada. My body has rooted in South London."[11] In work that can address the broadest social issues or most intimate personal experience, Gupta makes series of photographs, which are often presented in diptychs, about these multiple

Sunil Gupta, *Queens, New York / Albert Embankment, London*, 2001 / 3, from the series *Homelands*, digital color print, 59 x 25½ inches, courtesy of the artist

photojournalistic, documentary or street photography approach, in their investigation of contemporary cultural conditions. But they insist on an acknowledgement of a subjective filter through which the world is interpreted. With roots in street photography nurtured in New York by mentors such as Lisette Model, Sunil Gupta began his early career intending to engage in what he called "a form of liberal photojournalism." Yet he was troubled by both the superficiality of traditional photojournalistic narrative and the ease with which it could become touristic or ethnographic. Gupta began to focus more intently on social issues that resonated with his personal experience as an HIV-positive gay man and with an identity shaped by his multinational experience. (Gupta has dual Canadian and Indian

national identities and the challenges of navigating the intricate labyrinth of each nation's subcultures. In his *Homelands* series, Gupta juxtaposes images of places he had called home over the years, including northern India, the northeastern United States and eastern Canada. He does this not simply to create East / West dualities, but to explore a variety of resonances between the pictures, from compositional relationships to private associations. Throughout, the personal and global specter of HIV remains a constant.

Vivan Sundaram's political engagement through art has addressed major events in India's recent history. His large series of sculptures references the 1992 destruction of the centuries-old Babri mosque in the northern Indian town of Ayodhya, and subsequent rioting that killed thousands. But he also has engaged

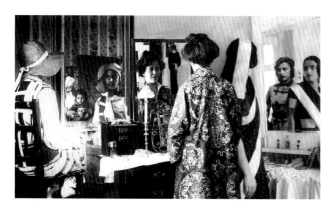

Vivan Sundaram, *Re-take of Amrita – Bourgeois Family – Mirror Frieze*, 2001, archival digital inkjet print, 15 x 26 inches, courtesy of Sepia International

I drench, soak, douse, moisten, quench, dilute, dampen, cleanse, or purify…. How it contains or is contained."[15] Through the quiet simplicity depicted by photographs of Bhalla's performance, the physical becomes transcendent and the mundane becomes mystical. The act of submersion becomes ritualized on many levels, addressing deeply personal experience, environmental issues, and the long tradition of bathing and submersion in Hinduism.

While Bhalla's series is more self-reflective and philosophical, many artists use a performance element in their photographs and videos to analyze and critique the construction of Indian identity in contemporary culture. They often use references to

in very personal, subjective historical narratives based on his own illustrious family. Sundaram mines his own family archive for images that he digitally manipulates and combines to create a new history of constructed family narratives. In a process Sundaram describes as "digital cloning," figures of himself as a child, his aunt Amrita, his mother Indira and his grandparents appear and reappear in different contexts, transcending time and place.[12] From an archive of images made by a family savvy and reflective about self-representation and multifaceted identity, Sundaram takes the level of subjectivity a step further by constructing new, imagined documents of family history that acknowledge the complex layers of his mixed cultural experience.[13] "The family album, in the age of the digital," writes Sundaram, "makes possible a return to the past, enabling re-imaging real and fictional narratives."[14]

One prominent strategy within this constructive mode of image-making is to incorporate performance into the artistic process. Most often, artists themselves perform the acts that are recorded through their photography and video. Atul Bhalla's series of sequential self-portraits, which are part of a larger body of work centered on the theme of water, is conceptualized with simple, open-ended statements such as "my work is an attempt to understand water. How I perceive it, feel it, eat it, drink it, wash in it, bathe in it, swim, wade, sink or will drown in it. How

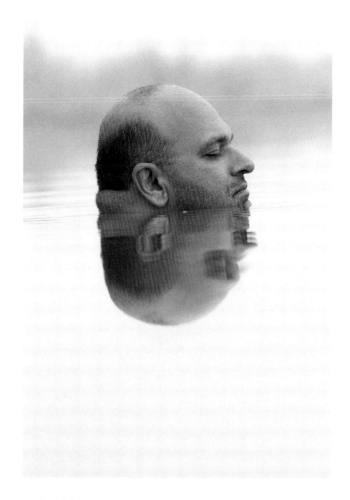

Atul Bhalla, *I Was Not Waving But Drowning II*, 2005, from a series of 14 photographs, 7½ x 11 inches each, courtesy of the artist

the categorization of social types. While the consideration of a postmodern fragmentation of self and socially constructed identity have been the focus of cultural criticism for many decades, the rapid globalization of the last decade makes these issues especially relevant in contemporary India. Indeed, many observers identify the forces of globalization and religious fundamentalism as among the major influences in contemporary Indian culture.[16] With globalization and the growth of a more privileged Indian middle class, traditional delineations of caste and class are faltering socially and economically. In the wake of these changes, Indian artists seem to feel freer to share topics and methods of critical analysis with artists around the world. They more openly explore formerly taboo subjects such as gender and sexuality; they unhesitatingly question religious and political power structures and belief systems; and they rigorously investigate the increasingly entangled local, national and global forces shaping contemporary experience. The interplay of cultural observation and critical analysis is a complex and calculated dialogue of give and take. Many artists, savvy about the postcolonial analysis of race, class, gender, are wary about playing into these easily clichéd categories by addressing notions of "Indian-ness" within a larger global context. As video artist Tejal Shah puts it, "I don't want to play into the idea that I am an Indian." But, she adds, "I have the right to claim my Indian-ness the way I want, without worrying about what another person expects or does not expect. If I feel it is relevant to my work or ideas I am thinking about, then it is okay."[17] Considering both subject matter and theoretical approach, Pushpamala N. asks, "Why should Indian artists…be restricted to our ethnicity? Why can't we take from forms current elsewhere and use them to break the norms here and to intervene in our reality?"[18]

Adopting strategies of masquerade shared with colleagues such as American artist Cindy Sherman and Yasumasa Morimura of Japan, Pushpamala N. engages exemplars of womanhood presented in Indian cinema, literature and other aspects of Indian visual culture.

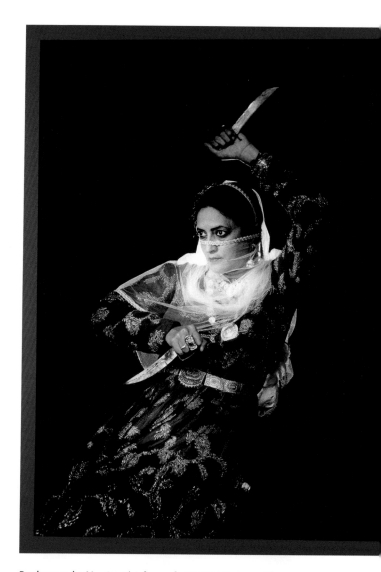

Pushpamala N., *Roudra* [anger], 2000 / 3, from *The Navarasa Suite*, set of nine sepia-toned black and white photographs, 26 x 20 inches, photography: J.H. Thakker and Vimal Thakker, India Photo Studio, Mumbai, courtesy Shumita and Arani Bose Collection, New York

She choreographs self-portraits and sequences of photographs in which she plays roles varying from wistful lover to swashbuckling heroine and picturesque villager. Pushpamala N. builds ambiguous narratives with contexts that recall the props and crudely painted backdrops of vernacular studio photography, the kitschy charm of Raja Ravi Varma paintings and the melodrama of Bollywood film stills. As M. Madhava Prasad observes, Pushpamala N.'s imagery drawn from popular culture appeals to "the collective memory of

a modern nation's urban citizenry, a memory embodied in images."[19] Yet her references are not direct quotations, but rather evocations of generally understood vocabularies, and her work can create even deeper associations than the shared experience of popular culture. This multifaceted system of references is especially apparent in *Navarasa Suite,* a series of nine images that combine the conventions of classic Bollywood studio portraiture and types with allusions to characterizations of the nine *rasa*s – the essential human emotions from traditional Sanskrit literature and drama.[20] Beyond allusions to shared visual high and low culture, the artist's multivalent masquerade also considers processes of (or perhaps the impossibility of) constructing individual female identity from fragmented cultural ideals. In a satirical play on early post-Independence family values, Pushpamala N.'s film *Rashtriy Kheer & Desiy Salad* draws inspiration from old patriotic recipe books that suggest the two dishes named in the title, which are based on colors of the Indian flag. The ideal family of a rigid military officer father, hugely pregnant mother and precocious, slightly mischievous son buzz in and out of each scene writing passages on a blackboard. Each reflects concerns of the particular character. The mood of Pushpamala N.'s parody of dogmatic patriotism of the middle of the previous century is endearingly silly, but at the same time conjures much more troubling associations with present-day religious and political hardliners.

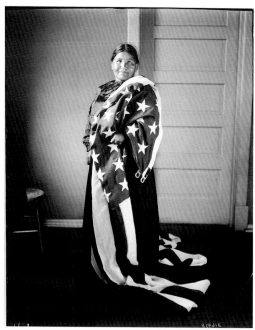

Photograph from the Wanamaker Expedition, 1913
AMERICAN INDIAN WEARING FLAG

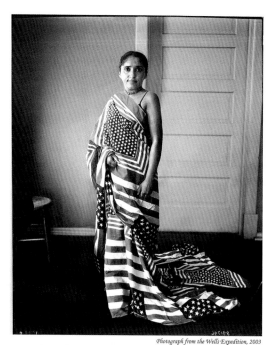

Photograph from the Wells Expedition, 2003
INDIAN AMERICAN WEARING FLAG AS A SARI

Annu Palakunnathu Matthew, *Flags*, 2003, from *An Indian from India*, archival digital print, inkjet on concorde rag, 12 x 16 inches, [on left, photograph from the Wanamaker Expedition, 1913, courtesy of the American Museum of Natural History, New York], courtesy of Sepia International

Anita Dube and Annu Palakunnathu Matthew use performance, self-portraiture and typification similar to Pushpamala N. Dube describes the "political imperative" of her work that leads her to "push the intellectual project to confront every and all aspects of power as one encounters them." A ritualized performance is seen in much of her work, with her body often serving as what she calls a "micro site for macro forces."[21] This contemplation of power through performance is perhaps most forcefully explored in her video *Kissa-e-Noor Mohammed (Garam Hawa)* with its parenthetic title referring to the classic 1973 film about the impact of Partition on a Muslim Indian family. Dube plays "Noor Mohammed," a character whose focus over the course of his monologue goes from a friendly and unassuming biographical history to a lamentation of religious fundamentalism and fascism. Yet the piece delves much deeper than obvious commentary on intolerance and religious violence. Playing the male role, Dube raises questions of gender and patriarchal structures, while Pushpamala N. in *Navarasa Suite*, references the nine essential *rasa*s of Indian aesthetics in literature and the performing arts. In her series, *An Indian from India*, Annu Palakunnathu Matthew juxtaposes her own image with nineteenth- and early twentieth-century photographs of American Indians. Imitating the romanticized ethnographic styles of the past in composition and costume, Matthew engages her "otherness" as an Indian living in the U.S. "The images highlight assimilation, use labels and make many assumptions," she writes. "I pair these with self-portraits in clothes, poses and environments that mimic these 'older' images.... I challenge the viewer's assumptions of then and now, us and them, exotic and local."[22] It is not easy for the audience to overlook political, social and historical commentary when the artists so obviously fabricate the images.

Video is an emerging art medium in India. It has been embraced much more recently than in the West, but with intense enthusiasm.[23] The expressive and analytical potential within video art's performance aspect has been of particular interest to Indian artists.

Video seems an especially apt medium for cultural critique, for personal expression and to examine the intersection of the internal and external worlds. Many recent observers have noted the high proportion of women artists in India choosing to work in video. According to historian Arshiya Lokhandwala, many female video artists find the medium can be a tool of personal expression while "gesturing toward broader postcolonial and socio-political contexts in India and elsewhere. For these women artists, video becomes an allegorical medium to articulate concerns about existing norms and traditions."[24] Indeed, the performance of constructed narratives possible in video is especially effective in exploring and critiquing forces that define cultural categories of gender and sexual identity.

Tejal Shah, *Trans-*, 2004–5, two-channel video, 12:00, courtesy of Thomas Erben Gallery, New York & Galerie Mirchandani + Steinruecke, Mumbai, collection of the artist

Tejal Shah recalls studying abroad and feeling a "strange sense of 'not belonging' or 'isolation.' That is why the question of identity, questions of who I am arose. Was it a physical space, was it something I could carry with me, or was it something I could make? Did it matter where the actual geography of home was? Hence all these questions were about transit, about identity that was in flux." In addition to questions of national and personal identity, video offers her a way to explore a feeling of affinity for those outside the

norms of sexuality, gender and class, extending beyond socially constructed boundaries.[25] With its fluid morphing of a similarly dressed man and woman on twin video monitors, *Trans-* reflects these processes of the fluctuation of identity across gender lines. For Sonia Khurana, video offers a new means of expression with a temporal and performance focus: "Painting alone," she explained, "wasn't sufficiently consummating my creative faculties. ... Video is a ready medium to explore the phenomenological dimension of time as well as stillness."[26] Video also allowed her to explore cultural exchange, including collaborative works created in Holland, Cameroon and South Africa. In works such as *Head / Hand* and *Tantra*, Khurana shows how video can be both

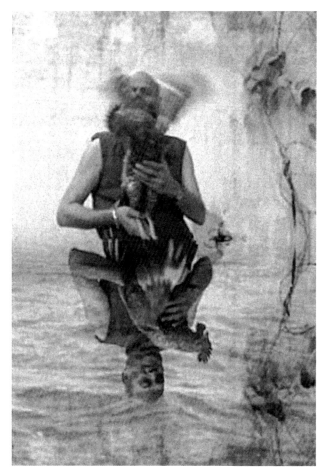

Ranbir Kaleka, *Cockerel-2*, 2004, single-channel video installation, 6:00, actor: Ram Gopal Bajaj; cockerel: Mustapha; digital compositing and video stills: Riverbank Studios, New Delhi, courtesy of the artist

inscrutable and revelatory. The associations conjured up by playful touches of an Indian hand on an African head can vary from sweet flirtations to a consideration of postcolonial identity and globalization. The slow metamorphosis from abstract form to figure in *Tantra* echoes the interconnection of the physical and the spiritual, not just in tantric practice, but also in the artist's work as a whole.

The subjective nature of both expression and reception is especially relevant to Indian artists working in new media such as video and Web-based technology. Video has the cinematic ability to transport the viewer into a deeper temporal experience than a singular photographic image. But, as critic Geeta Kapur has pointed out, this experience differs from cinema because it tends to be a solitary, sometimes awkward and uncomfortable experience.[27] This prodding discomfort can be intensified by works that deny traditional narrative flow and coherent reading and depend instead on enigmatic images, and multivalent interpretations. For instance, Navjot Altaf's *Lacuna in Testimony* references the riots of 2002 in Ahmedabad, the largest city in Gujarat. Those riots left thousands of Muslims dead or homeless, but she makes no attempt to create a reportorial narrative of the events. Instead, haunting, semi-intelligible murmuring testimonies of the events and abstracted images of ocean waves are intermingled with images of various catastrophes. This creates a purposeful opacity and calls into question the ability to document and understand through historical record. Ranbir Kaleka sees video as an extension and redefinition of the possibilities of painting. He freely blurs the boundaries of painting and video by making works of projections onto painted surfaces. "New technology," he writes, "has broadened the entire spectrum of expressive possibilities," with room for painting, sculpture, language, text, movement, performance and music.[28] Stressing dualities, mirroring and repetition, Kaleka's *Cockerel-2* plays on literal and symbolic dialogues between stasis and movement, capture and flight, possession and loss, material and dissolution.

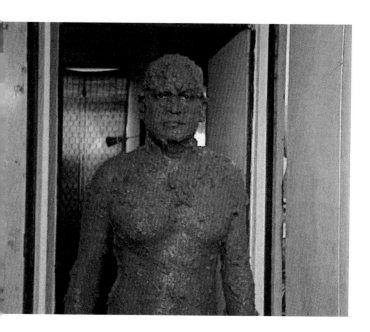

Subodh Gupta, *Pure*, 2000, single-channel video, 8:00, courtesy of the artist

multiplicities of personal, spiritual and national identity in India.

Many artists exploit the relative newness of video and interactive media to draw viewers in and make them more aware of their experience by extending self-conscious subjectivity from the artists' creative process to the viewers' experience of the work. But these artists do not simply consider how the audience views the work, but also who the audience is. They take into account how elements of the cultural identities of the artist and the viewer, both shared and distinct, will shape the audience's interpretation of the work. Indian art is by no means made in isolation. In virtually every case, artists dealing with Indian identity do so with an acute awareness of a dialog with larger, even global, artistic and cultural conditions. Indeed, many Indian artists possess an increasingly global perspective that anticipates a global audience, as in the case of Shilpa Gupta's interactive works. Gupta

Many of Subodh Gupta's works are self-referential and explore dualities in his own identity that are mirrored in modern India as a whole. A successful, internationally traveled and urban-dwelling artist, Gupta's roots lie in the largely agrarian state of Bihar, which is one of India's poorest regions. These two very different worlds meld in *Pure,* a mesmerizing video in which the artist stands in the shower of a modern apartment block. Because the video runs backwards and in slow motion, globs of cow dung rise into the frame and coat his body. Eventually, he is entirely caked in dung and walks through the apartment and onto the building's elevator. While the dung may seem repugnant to an urban dweller (especially a Westerner), it is an essential and valued resource in rural India, where it is used as fertilizer, insect repellant and fuel, when dried. As Gupta points out, "dung transcends its day-to-day associations as a waste element and defiler to become, in spiritual belief, a cleanser and atoner."[29] In *Pure,* the rural and the urban, the mundane and the ritual, the contemporary and the timeless collide. This makes it one of the most compelling contemplations of the complexities and

Shilpa Gupta, *Untitled*, 2004, interactive video projection with sound, courtesy of the artist

uses Web-based and interactive technology to take on international social issues by challenging her viewer to consider the moral implications of their actions. Works such as her 2000 *diamondsandyou.com* and 2002 *Your Kidney Supermarket* force participants to recognize human implications of global consumption.[30] Through a complex and often purposefully ambivalent array of visual and interactive tactics, many of Gupta's works simultaneously address issues ranging from constructed gender identities to global consumerism and violent political upheaval. Her untitled interactive work of 2004–5 sparks a controlled digital dialog between the viewer and seven moving images of the artist wearing various stereotypical uniforms and costumes made from camouflage cloth. Voyeuristic manipulation of sexualized types and the stylized militarism of camouflage as fashion merge into an elaborate exploration of cultural and individual identity in the hands of an active viewer. Gupta further complicates the viewer / artist interaction and role-playing. The game-like point-and-click interface gives the viewer more of an illusion of control than actual control of the marching, squatting, shooting figures and barrage of scrolling textual commands and demands. By relinquishing less power to the viewer than it might at first seem, the artist encourages viewers to reflect not simply upon the artist's identity and agency, but also upon their own.[31]

Indian photographers and video artists of the past quarter century have defined a multifaceted array of tactics through which they can engage the complexities of Indian cultural and personal identities. Increasingly, they insist that their work be more than simply a visual record that mirrors an easily discernable world. Instead, they assert that their media be a tool by which one can observe and analyze critically, to construct subjective histories, and to make self-reflective, introspective and philosophical expressions. With insightful self-consciousness and remarkable poignancy, along with honesty, audacity, wit and irony, these artists are creating works with many levels of meaning that allow for thoughtful subjective interpretation. They employ complex references from within Indian culture and without, and embrace new media that reveal new possibilities to engage audiences. Like a clouded mirror, this work has conceptual depth. It encourages us to peer deeply within and to look beyond the surface, and to consider India anew.

NOTES

[1] The desire to avoid clichés in cross-cultural reception is not unique to Indian photography. Okwui Enwezor writes of African photographers who deny "the viewer the violent spectacle of deprivation and depravity that has constituted the signature visual image of Africa," and instead "evidence a subtle yet substantial critique of such images." Okwui Enwezor, *Snap Judgments: New Positions in Contemporary African Photography* (New York and Göttengen Germany: International Center of Photography and Steidl, 2006), p. 19.

[2] Yves Véquaud, *Henri Cartier-Bresson en Inde* (Paris: Centre National de la Photographie, 1985).

[3] From unpublished Artist's Notes, 2006.

[4] Singh quoted in "Conversation: V.S. Naipaul and Raghubir Singh" in Raghubir Singh, *Bombay: Gateway of India* (New York: Aperture Foundation, 1994), p. 5.

[5] Rahman's flair for formal arrangement is evidence of his MIT and Yale training in both photography and graphic design. His marriage of concern for compositional structure and vernacular subjects reflects his admiration for photographers like Walker Evans. See Chidananda Dasgupta, "Infinite Shades and Honest Encounters" in *Ram Rahman: Photographs* (New Delhi: Shridharani Gallery, 1988).

[6] For an insightful discussion of the primacy of popular visual culture and its relation to art in India, see Ashish Rajadhyaksha, "Visuality and Visual Art – Speculating on a Link," in Chaitanya Sambrani et al., eds., *Edge of Desire: Recent Art in India* (London: Philip Wilson Publishers, 2005), pp. 162–3.

[7] Ketaki Sheth in *Indian Women Photographers. Photographers International*. Taipei, Taiwan, December 1997, pp. 74–5.

[8] Unpublished Artists' Statement. Samar Singh Jodha's projects of cultural analysis are in addition to his career as a successful commercial photographer working with major corporate clients.

9 See Satish Sharma, "Sheba Chhachhi," *Indian Women Photographers*, pp. 24–5 and Sheba Chhachhi, "Feminist Portraiture," in Sunil Gupta, ed., *An Economy of Signs: Contemporary Indian Photographers* (London: Rivers Oram Press, 1990), pp. 47–59.

10 In recent years, Singh has made it a point to avoid large group exhibitions and the categorization of her work by nationality and prefers to show her work in very controlled settings that preserve her photographs' intimate moodiness. Author's conversations with the artist, January 2004–July 2006.

11 Sunil Gupta, *Pictures from Here* (London: Chris Boot Ltd., 2003), pp. 8–10. (Gupta has recently made New Delhi his primary residence.)

12 Vivan Sundaram, "Preface," *Vivan Sundaram: Re-take of Amrita* (New Delhi: Tulika Books, 2001), pp. 6–7; and "Illumination and Death," *Vivan Sundaram: Re-take of Amrita* (New York: Sepia International and the Alkazi Collection, 2006), pp. 9–11.

13 See Sundaram in Johan Pijnappel, ed., *Crossing Currents: Video Art and Cultural Identity* (New Delhi: Royal Netherlands Embassy and The Mondriaan Foundation, 2006), p. 134.

14 Sundaram in *Video Art in India* (Calcutta: Apeejay Press, 2003), p. 90.

15 Unpublished Artist's Statement, October 1, 2005.

16 See for instance, *Edge of Desire: Recent Art in India*, p. 23.

17 From interview with Tejal Shah in *Crossing Currents: Video Art and Cultural Identity*, p. 125.

18 From "National and Global," *Pushpamala N: Indian Lady* (New York: Bose Pacia, 2004).

19 M. Madhava Prasad, "The Last Remake of Modernity?" in *Pushpamala N: Indian Lady*.

20 The photographs were taken by J.H. Thakker and his son Vimal, the Bombay studio photographers of famous cinema stars in the 1950s.

21 From "Anita Dube: An Interview with Peter Nagy" in *Icon: India Contemporary* (New York: Bose Pacia, 2005), pp. 23–5.

22 From Artist's Statement, www.annumatthew.com.

23 Art historian Johan Pijnappel has traced Indian video art through pioneering artists such as Vivan Sundaram, Nalini Malani and Navjot Altaf, some of whom had training in filmmaking. This new medium allowed a variety of different explorations from historical and political commentary, to more and more deeply personal and abstracted mélanges of images. Johan Pijnappel, "Imaging Truth and Desire: Indian Video Art" in *Video Art in India*, pp. 22–33. See also Pooja Sood, "Beyond the Cube" in *Video Art in India*, pp. 14–9.

24 Arshiya Lokhandwala, *Rites / Rights / Rewrites: Women's Video Art from India* (Durham, North Carolina: John Hope Franklin Center for Interdisciplinary and International Studies, Duke University, 2005), p. 6.

25 From interview with Tejal Shah in *Crossing Currents: Video Art and Cultural Identity*, pp. 125, 127.

26 Quoted in Johan Pijnappel, "Imaging Truth and Desire: Indian Video Art" in *Video Art in India*, p. 25, from Alka Pande, "Like a Bird on a Wire" *Art India,* Vol. V, Issue IV, 2000.

27 Geeta Kapur, "Inside the Black Box: Images Caught in a Beam," Paper delivered at Jawaharlal Nehru University, Delhi, November 10, 2005.

28 Kaleka in *Crossing Currents: Video Art and Cultural Identity*, p. 78. See also Michael Wörgötter, "Casting Anchors in the Digital Flood of Images," *Ranbir Kaleka: Crossings* (New York: Bose Pacia, 2005), pp. 9–10.

29 Subodh Gupta in *Crossing Currents: Video Art and Cultural Identity*, p. 76.

30 See interview with Shilpa Gupta in *Crossing Currents: Video Art and Cultural Identity*, pp. 50–9.

31 See Shuddhabrata Sengupta, "Lipstick and Camouflage: The 'Shilpa Gupta' of Shilpa Gupta" in *Shilpa Gupta* (New York: Bose Pacia, 2006), pp. 23–36.

CATALOGUE

India's engagement with the lens-based images of photography, the cinema, and most recently video art, is complex and rich. The first known photo studio in India opened in 1849, and the first feature film in India was made in makeshift studios, during the silent era, in 1912. While photography has been established for more than 150 years in India, video art has been late to develop. Media technology has seen a generational shift. It has gone from the transistor radio suspended from the village bicycle to the world's largest multilingual film industry and a colossal home-grown television network. It also has shifted from an onslaught of cell phones to legions of software engineers seamlessly binding Bangalore (now Bengaluru) to Silicon Valley. *Public Places*, *Private Spaces* focuses on the work of photographers and video artists since the 1980s. The visual density of the Indian landscape, both physical and social, offers opportunities to create different kinds of photographic genres. This includes everything from straightforward photojournalism to highly contrived subjective expression.

Moving away from the expected image of India, which might conjure up natural disaster or political upheaval, the exhibition examines the artists' forays into the forces shaping contemporary identity. Along the way, these artists traverse many subcultures and forms of representation, from the inescapable shared spectacle of Bollywood and political imagery in public space to photographs in which the artists themselves perform for the camera. As a result, the lens moves from the street to the home and from the body politic to the body of the artist. This creates new ways of engaging India.

STREET PHOTOGRAPHY AND A SO

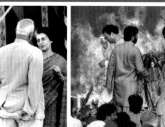 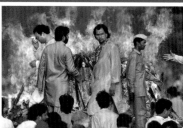 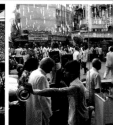

Lenin Stalin Ho Ch

The foundations of street photography were laid in the 1980s in the work of Raghubir Singh and Raghu Rai. They bring to photography the aesthetic of the street in which seemingly instinctual senses of timing and composition come together to create democratic and direct images. In Rai's images, the monumental and the incidental are equally striking, and the viewer is able to apprehend a uniquely humanized understanding of even the most momentous historical events, such as the assassination of Indira Gandhi. The complex layering of space in Singh's compositions, which often incorporate reflections and juxtapositions of interior and exterior, call as much attention to the photographer's conceptual process of building an image as to the activity on the street. In the hands of younger photographers such as Manish Swarup, this tradition of street photography remains vital. With an eye for immediacy and poignancy, Swarup makes ironic contrasts between the inflexions of sudden social upheaval and the rhythms of everyday life.

From the locus of the street, Ram Rahman fashions himself as a wry and ironic commentator on Indian public life and its conflation of religion, politics and popular art. Other artists focus on realms of Indian society that might otherwise remain unknown to a wide audience. This includes Ravi Agarwal's photo essays on Gujarati laborers and Vivek Vilasini's portraits of villagers from Kerala. In the last decade, Indian artists also have begun to see video as a language with which they can engage this world. Gigi Scaria's examination of the lives of young ragpickers and Surekha's portrayal of a woman who plants and tends trees reveal a dual, sometimes paradoxical, relationship between the urban and the rural, as well as the visibly modern and the "eternal" India. For Navjot Altaf, video is used to investigate notions of coherent narrative and fixed truth in the context of crucial historical events.

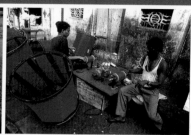

eze · Marx · Che Guevara · Gramsci

Raghu Rai

Raghu Rai is one of the foremost master photographers of our time and an artist of profound intelligence, spirituality, and compassion.... His work is unfettered by the specifics of place or time. While his native India may provide the principal setting for his images, his subject is humanity on a universal scale. His photographs focus on the relationship of spirit and experience – as he eloquently puts it, "moments of substantive contact with the world."

<div align="right">– Michael E. Hoffman [1]</div>

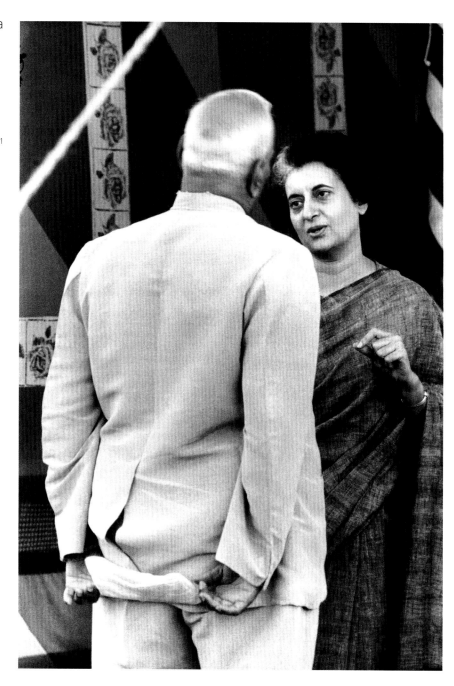

▶ Raghu Rai, *Mrs. Gandhi with the then President Mr. V.V. Giri*, 1974, 20 x 24 inches, courtesy of the artist

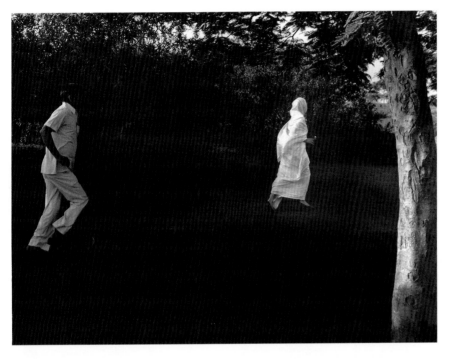

◀ Raghu Rai, *Indira Gandhi at her Residence*, 1984, 20 x 24 inches, courtesy of the artist

▼ Raghu Rai, *Army Generals Preparing for Indira Gandhi's Funeral, Delhi*, 1984, 20 x 24 inches, courtesy of the artist

▼ Raghu Rai, *Rajiv Gandhi at the Funeral Pyre of his Mother, Indira Gandhi*,1984, 20 x 24 inches, courtesy of the artist

Manish Swarup

The Gujarat riots in Ahmedabad were the gory aftermath of the Godhra train incident. Who is to blame? While the government is still trying to fix liability, a silent fear still lurks in the hearts of the people.

 – Manish Swarup [2]

▲ Manish Swarup, *Family through Barred Door, Gujarat*, 2002, 20 x 16 inches, courtesy of the artist

◄ Manish Swarup, *Boys in Shadow, Gujarat*, 2002, 16 x 20 inches, courtesy of the artist

Wrestling, a pastime of kings, is a
dying sport in its country of origin.
These wrestlers train in local
*akhara*s and participate in local
competitions with minimal funding
and scholarships.

– Manish Swarup [3]

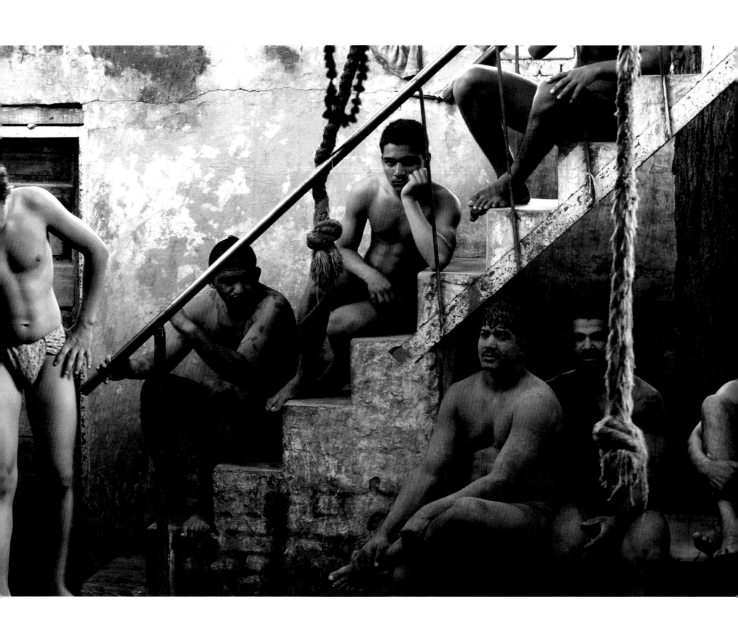

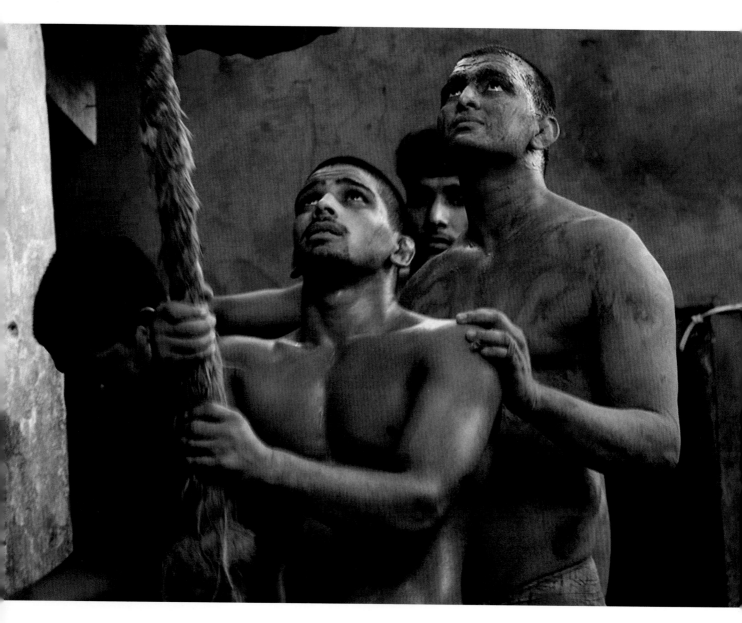

▲ Manish Swarup, *Wrestlers with Rope*, 2002, 16 x 20 inches, courtesy of the artist

◄ Manish Swarup, *Wrestlers on Steps*, 2002, 16 x 20 inches, courtesy of the artist

Raghubir Singh

He blocks our vision of something
we might want to see and then
instead shows us something
formerly unimportant, in other
words he reverses hierarchies. He
pits old against new. He makes
gazes collide into a network of
directional arrows – a constant
ping-ponging. He uses light in a
way that appears holy. His
employment of color should make
some painters envious and his shifts
in space call to mind Velasquez. I
could go on and mention how he
uses signage as text, his multi-
narratives, his Orson Wellesian
juxtaposition of near and far. What
is remarkable is that most
photographers can successfully
employ only one or two of these
strategies. Raghubir Singh can
summon them all at precisely the
right instant.

<div align="right">– John Baldessari [4]</div>

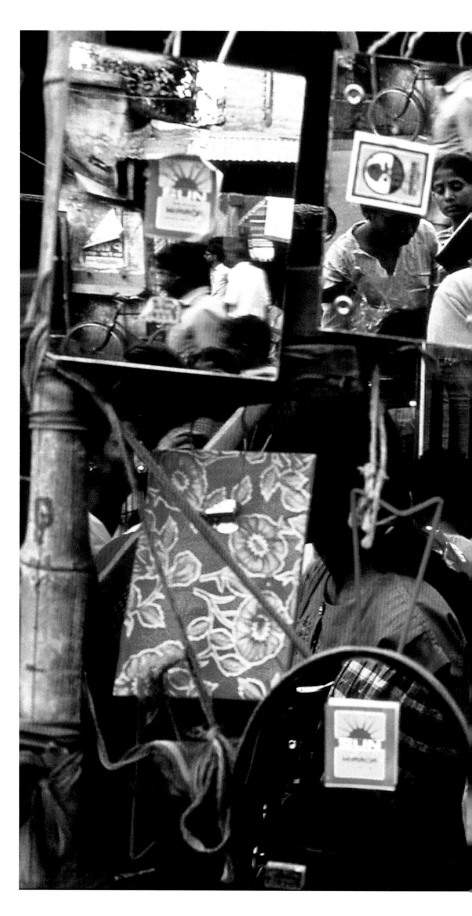

▶ Raghubir Singh, *Pavement Mirror
Shop, Howrah, West Bengal*, 1991,
36 x 60 inches, © Succession Raghubir
Singh

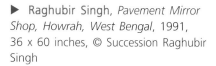

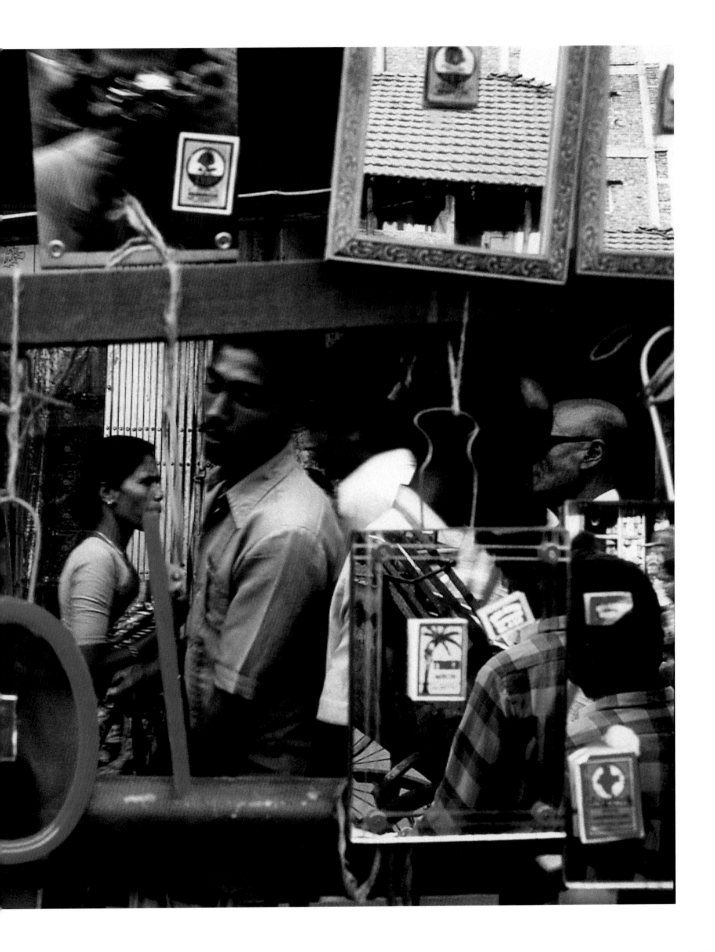

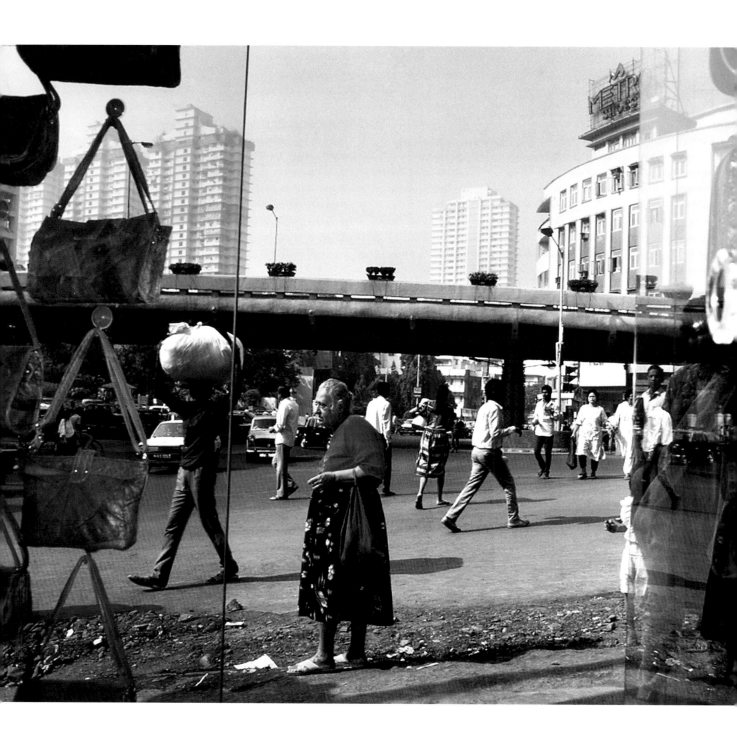

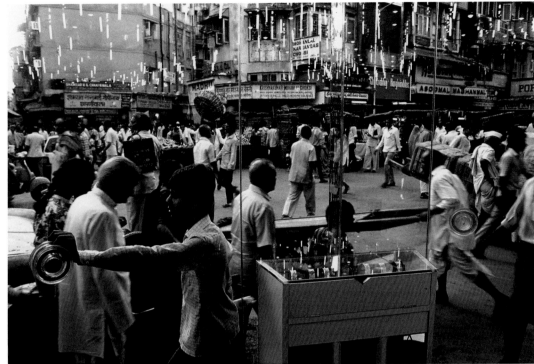

▲ Raghubir Singh, *Zaveri Bazaar and Jeweler's Showroom*, 1991, 36 x 60 inches, © Succession Raghubir Singh

◄ Raghubir Singh, *Kemp's Corner from a Leather Goods Shop, Mumbai, Maharashtra*, 1989, 36 x 60 inches, © Succession Raghubir Singh

Ram Rahman

In Ram's work the patina of city
walls, graffiti and posters, hoardings
and billboards – all components of
an ephemeral visual culture,
compete for attention. His language
is in a sense anti-pictorial and an
instinctive rejection of the cliché of
eternal India. In building bodies of
work on the political party and the
social party, he compels a kind of
opinion formation through the
sheer act of viewership. Rahman
presents himself as commentator
on class issues, even as he, with the
same interjection of irony, enacts
the role of witness and participant.
 – Gayatri Sinha [5]

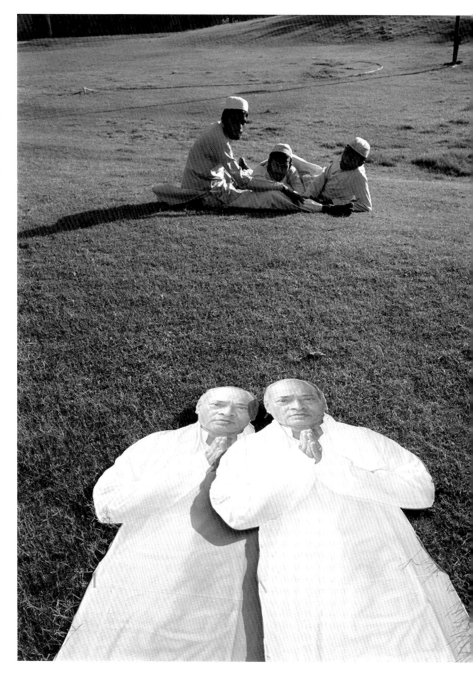

▶ Ram Rahman, *Narasimha Rao,
Old Delhi,* 1996, 20 x 16 inches,
courtesy of the artist

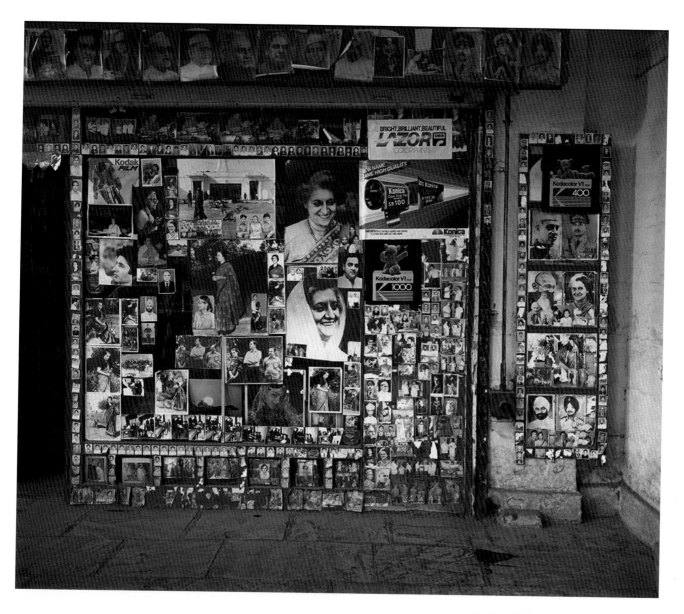

▲ Ram Rahman, *Capital Studios, Delhi*, 1986, 16 x 20 inches, courtesy of the artist

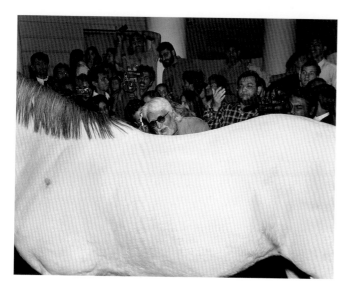

◄ Ram Rahman, *MF Husain Paints a Horse, Delhi*, 1994, 16 x 20 inches, courtesy of the artist

Ravi Agarwal

▲ Ravi Agarwal, *Kite String Making, Surat, Gujarat,* 1998, from the series *Down and Out: Migrant Labor in Gujarat,* 11 x 16 inches, courtesy of the artist

As I found myself in the company of some of the most politically and economically marginalized people, the process left me personally transformed at many levels. At one level was a sharing of the experience of their very quiet dignity and uprightness despite a very sparse material existence. At another, I could not but interrogate and negotiate my own position as a photographer trying to represent another, especially where I was clearly privileged in many ways.

– Ravi Agarwal [6]

▼ Ravi Agarwal, *Printing of Cloth, Surat, Gujarat*, 1997, from the series *Down and Out: Migrant Labor in Gujarat*, 11 x 16 inches, courtesy of the artist

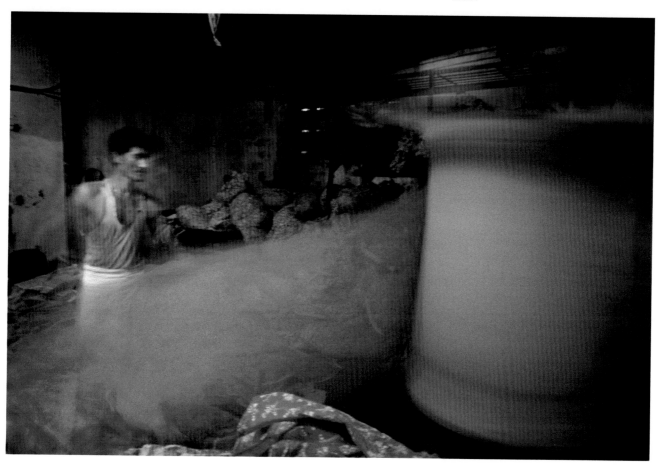

The city bears witness to itself. The river is in the margins. It is very dirty, filthy. The city does not need it any more. Its future is pre-configured, the river is dead. It will now be cleaned. Not like a life giving artery, but a sparkling necklace, adorning a new globality. The city is turning its back on the river even as it reconfigures its topology.

– Ravi Agarwal [7]

◄ Ravi Agarwal, *Refuse* from the series
Alien Waters, 2004–6, 11 x 16 inches,
courtesy of the artist

▼ Ravi Agarwal, *Interior* from the series
Alien Waters, 2004–6, 11 x 16 inches,
courtesy of the artist

Vivek Vilasini

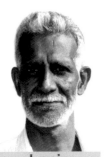 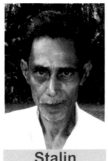 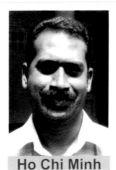 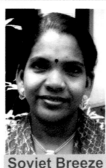 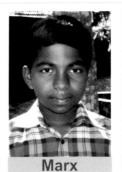

Lenin Stalin Ho Chi Minh Soviet Breeze Marx Che Guevara Gran

These are portraits of real people, and their real names are Marx, Lenin, Che Guevara, Soviet Breeze, etc. They all live in a village in Kerala, an Indian state with a long history of Marxist leanings. Vilasini speaks of the irony of this form of identity making, and the implications of the burden of history. "That all this naming is happening or has happened in a small village is what inspired me. The day I went to photograph Gorbachev, he had gone early to work in the paddy fields and Mao Tse Tung had a fight with the local party bosses and refused to be photographed...."

– Gayatri Sinha [8]

▲ Vivek Vilasini, *Between One Shore and Several Others*, 2005, series of 7 photographs 10 x 8 inches each, with name plates, courtesy of the artist

Gigi Scaria

I met Sohail aged 17 and Mariyan aged 14 at the NDMC Community Centre in Sarojini Nagar during their afternoon class organized by CHINTAN (an environmental research and action group, working with waste pickers in the city). I spent some time in the classroom talking to them and asking about their daily routine. They said they go every night to collect waste from near by places and work through the night till daybreak. …While portraying a late night tour with Sohail and Mariyan my video tries to establish a relationship with a world that we are not normally familiar with. This tour also signifies a search of the back door of an established social order representing the world of consumption.

<div align="right">

– Gigi Scaria [9]

</div>

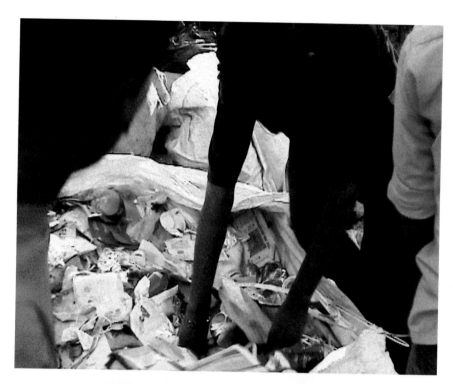

 Gigi Scaria, *A Day with Sohail and Mariyan*, 2004, single-channel video, 17:00, actors: Sohail Ali and Mariyan Husain, courtesy of the artist

Surekha

I don't have kids. When I was thirty, my husband and myself decided to plant these trees, to compensate, to fill the void in our life and to earn a sense of well-being.... It was out of our free-will that we had planted and were taking care of these four hundred trees.... Initially we planted ten sticks per year, watered it in the summer till the rainy season arrived. Both of us carried water to the plants all through the stretch of four miles. We carried water in mud pots, placed on our heads and waist. Gradually we increased the number of saplings to be planted annually. We stopped planting any more after, say, ten years. By then my husband had taken to illness. I managed to "spend" on cremating him after he passed away. From then on the bond between the trees and myself became more intense.

 – Thimmakka, the Tree Woman [10]

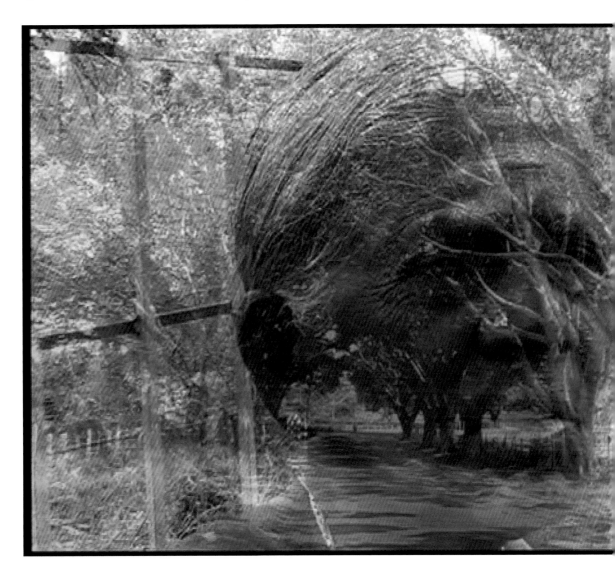

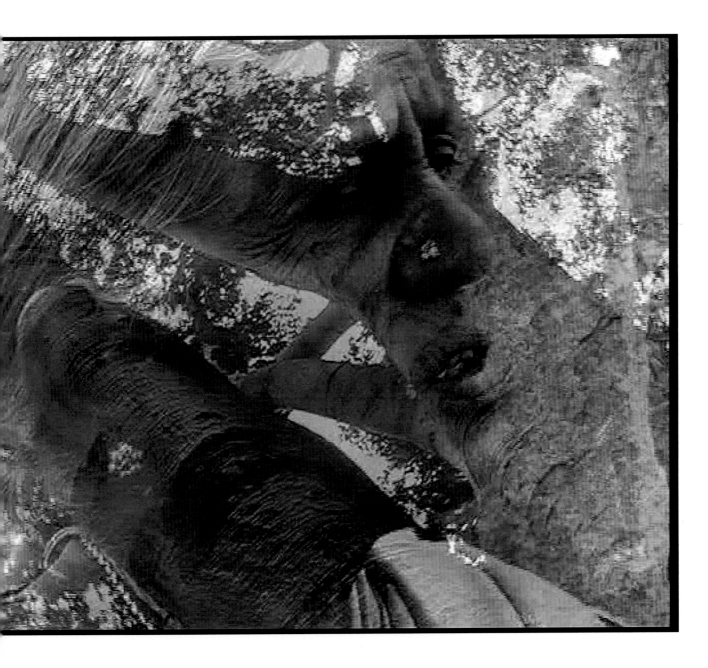

◄▲ Surekha, *Tree Woman*, 2005,
single-channel video, 4:30, courtesy of
the artist

Navjot Altaf

Over background of the sea, a grid of video and photographs of catastrophes appears, accompanied by murmuring fragments of testimony about the 2002 violence in Gujarat that left thousands of Muslims dead or homeless. While the images and words begin to give us access into historical events, they remain fragmentary, disintegrated. We are left to wonder if we can ever truly understand the world beyond our own experience.

<div align="right">

– Paul Sternberger
(for this volume)

</div>

 ▶ Navjot Altaf, *Lacuna in Testimony*, 2003, three-channel video installation with 72 mirrors, time variable, courtesy of the artist

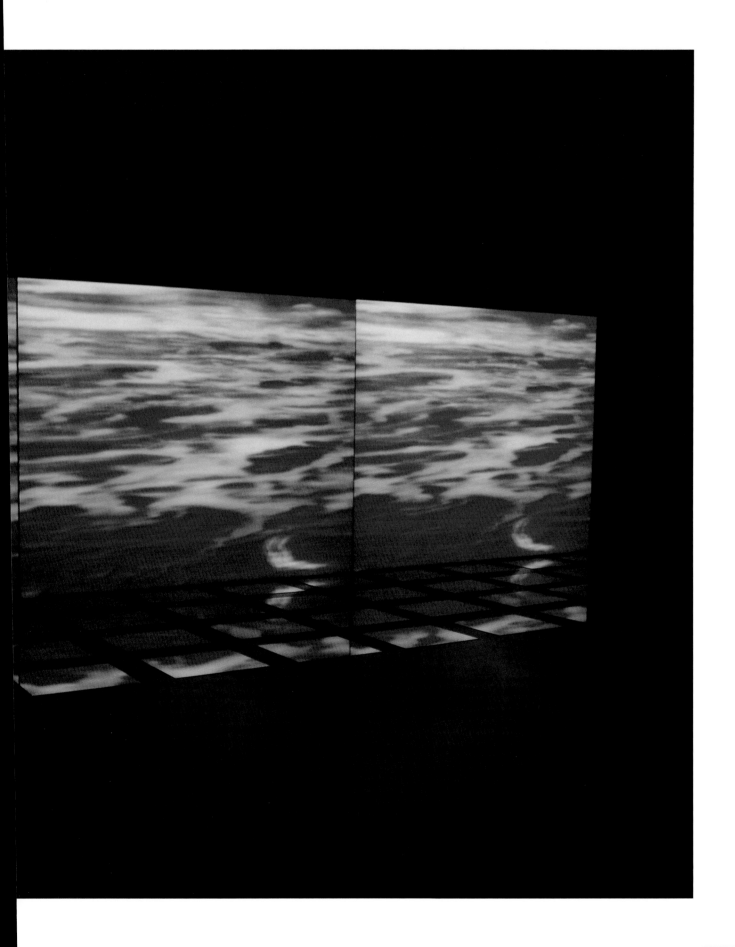

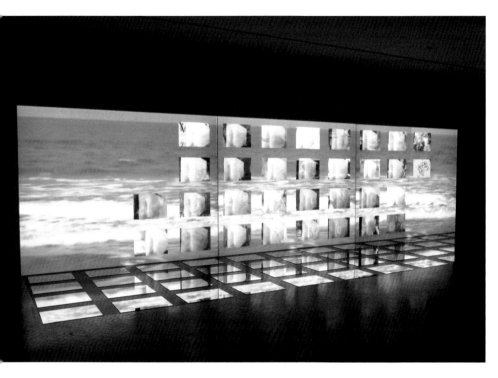

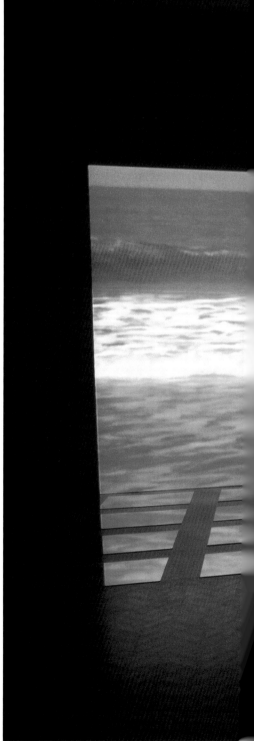

▲▶ Navjot Altaf, *Lacuna in Testimony*, 2003, three-channel video installation with 72 mirrors, time variable, courtesy of the artist

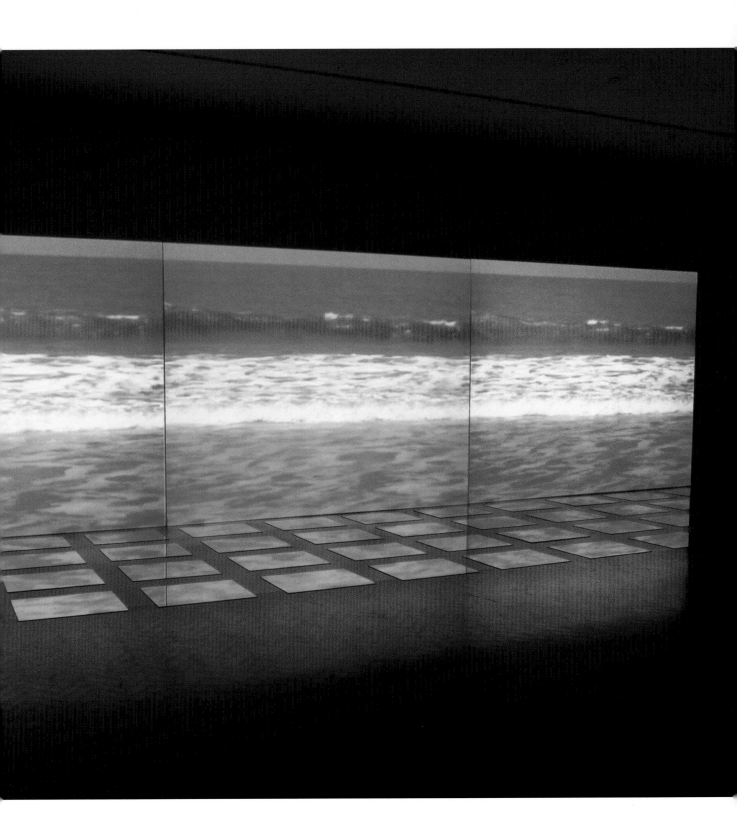

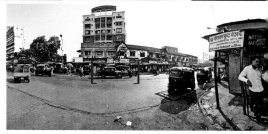

Recent art photography in India actively explores the way Indian popular culture shapes identity and invades the private realm. Among the most powerful and evocative sources are consumer culture and media images in film, advertising and television. Shahid Datawala and Rajesh Vora explore the interplay of Bollywood and the beauty industry as it extends beyond the cinema and television screen into the lives of ordinary people. By doing so, they reveal the vulnerability of those who aspire to the tinsel promise of fame. In a generous sweep, Samar and Vijay Jodha examine the omnipresence of the television as an object in contemporary living and working spaces.

Several Indian artists treat photography and video as overtly interpretive media that extend into social analysis. A recurring sign of this self-consciousness is the artists' use of their own image or of body as a site of artistic practice. Pushpamala N. examines the social tropes of the heroic feminine by performing for the camera and constructing fabular cinematic narratives. Jitish Kallat anchors his photographic exploration of the urban landscape with his own image squarely in the center of the streetscape. Cultural imperialism, patriarchy, gender and sexuality all become topics of investigation for Shantanu Lodh, Anita Dube and Tejal Shah, as they step in front of the camera and become not just makers of images, but part of the image themselves.

PRIVATE

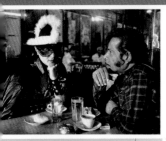

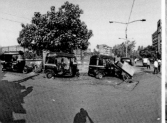

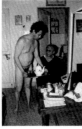

Shahid Datawala

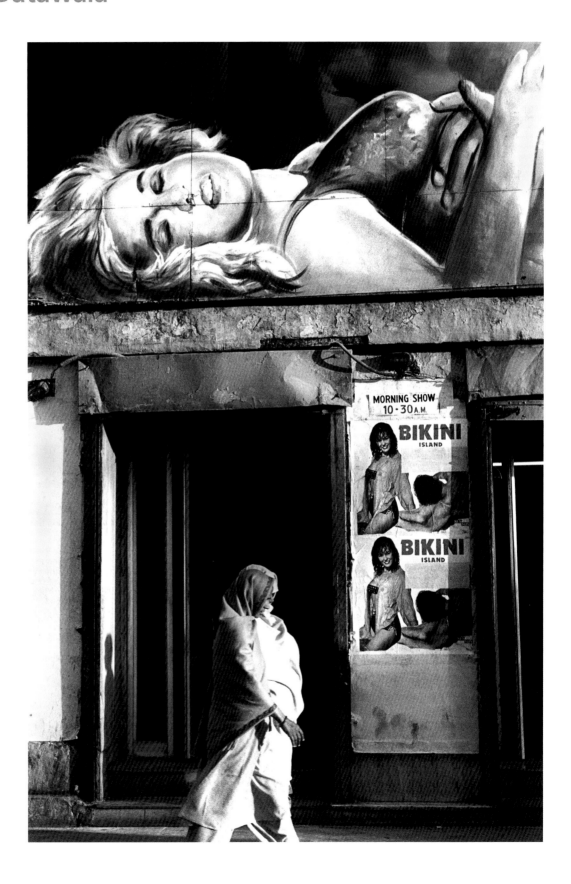

◀ Shahid Datawala, *Purdah Ladies*, 2003, 30 x 22 inches, copyright Shahid Datawala, courtesy Tasveer / Foss-Gandi

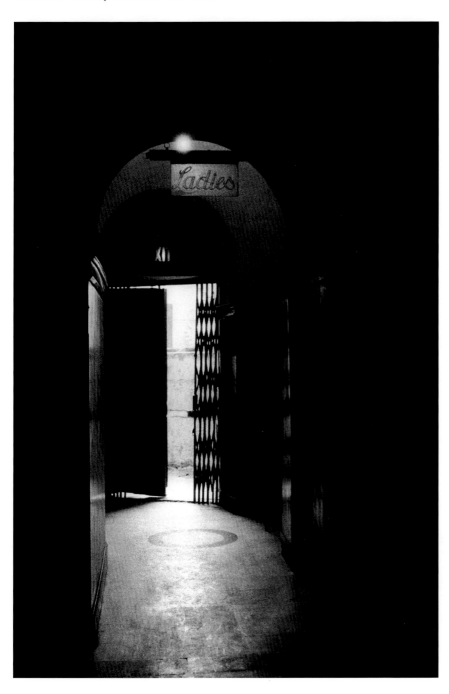

...For millions of Indians, wherever they live, a major part of "India" derives from its movies. Here, the cinema has provided, for the better part of this century, the most readily accessible and sometimes the most inventive forms of mass entertainment. In its scale and pervasiveness, film has borne, often unconsciously, several large burdens, such as the provision of influential paradigms for notions of "Indianness", "collectivity" (in the generation of an unprecedented, nationwide, mass-audience), and key terms of reference for the prevailing cultural hegemony.

– Ashish Rajadhyaksha and Paul Willemen [11]

◀ Shahid Datawala, *Ladies Toilet*, 2003, 30 x 22 inches, copyright Shahid Datawala, courtesy Tasveer / Foss-Gandi

▼ Shahid Datawala, *Regal Man*,
2003, 30 x 22 inches, copyright Shahid
Datawala, courtesy Tasveer / Foss-Gandi

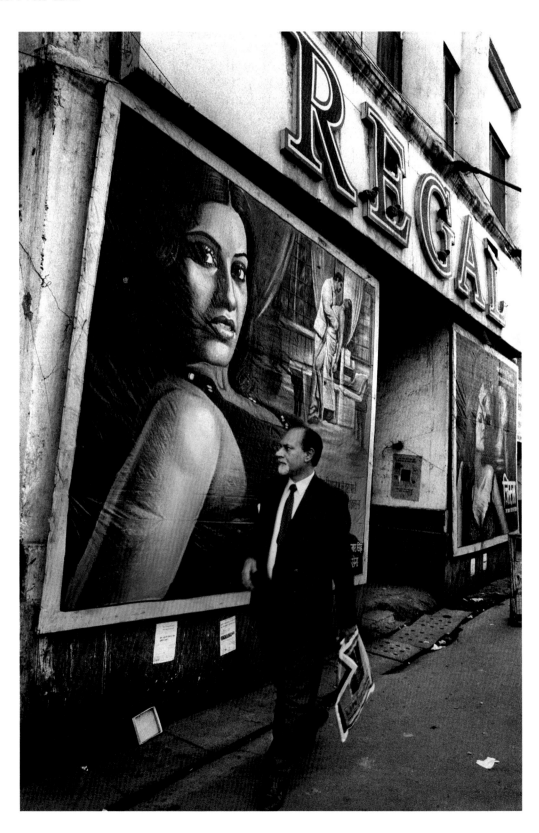

Rajesh Vora

▶ Rajesh Vora, *Look of the Year
Contest, Mumbai*, 1998,
11 x 14 inches, courtesy of the artist

▼ Rajesh Vora, *Hair Dresser
of the Year Awards, Mumbai*, 1998,
11 x 14 inches, courtesy of the artist

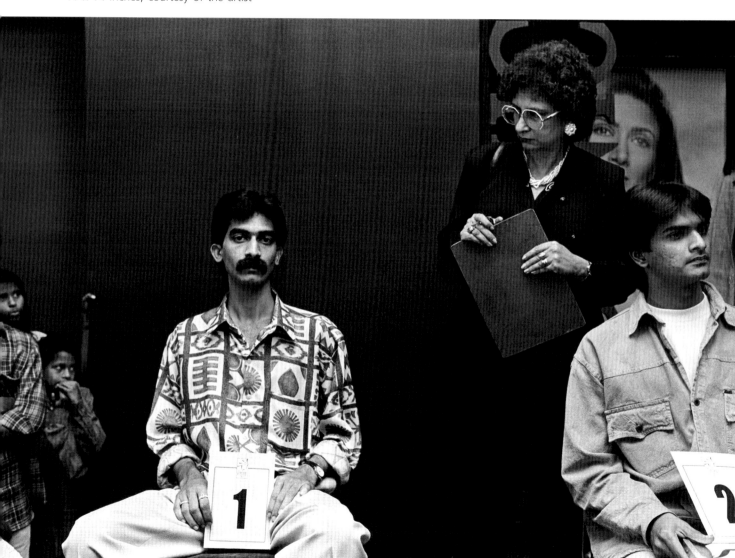

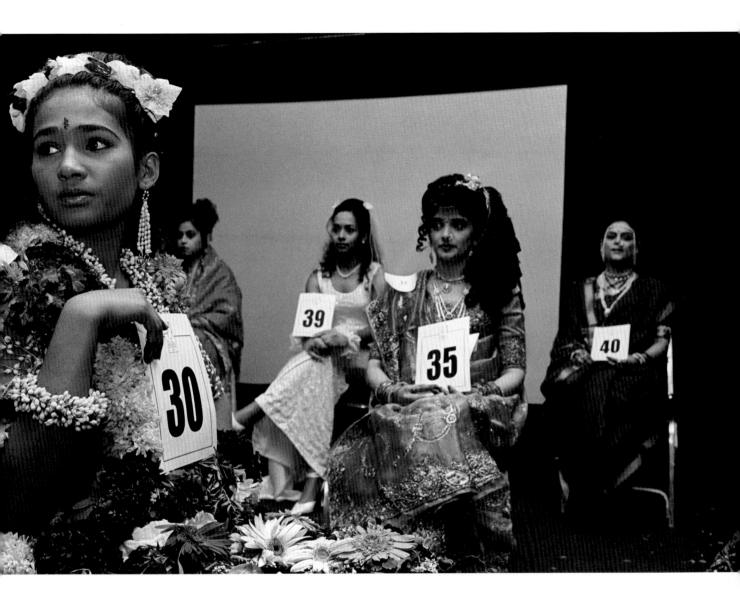

Over the past few years, traditional Indian society has been invaded by Western music and fashion, and by the cosmetic and fashion industries. With the winning of titles of "Miss Universe" and "Miss World" (twice in a row) by Indian beauties, the floodgates of globalization were thrown open. With this "planned" recognition, the cosmetic and fashion industries raised the hopes of the young generation, luring them to adorn themselves with their products, through the Western model of consumerism and materialism. The generation that was largely confined to indoors, living by the Indian customs and traditions, is rapidly shedding its veil of inhibitions. This global invasion gave wings to this generation's aspirations and many dream of walking in the footsteps of successful models and even Bollywood stars.

– Rajesh Vora [12]

Samar and Vijay Jodha

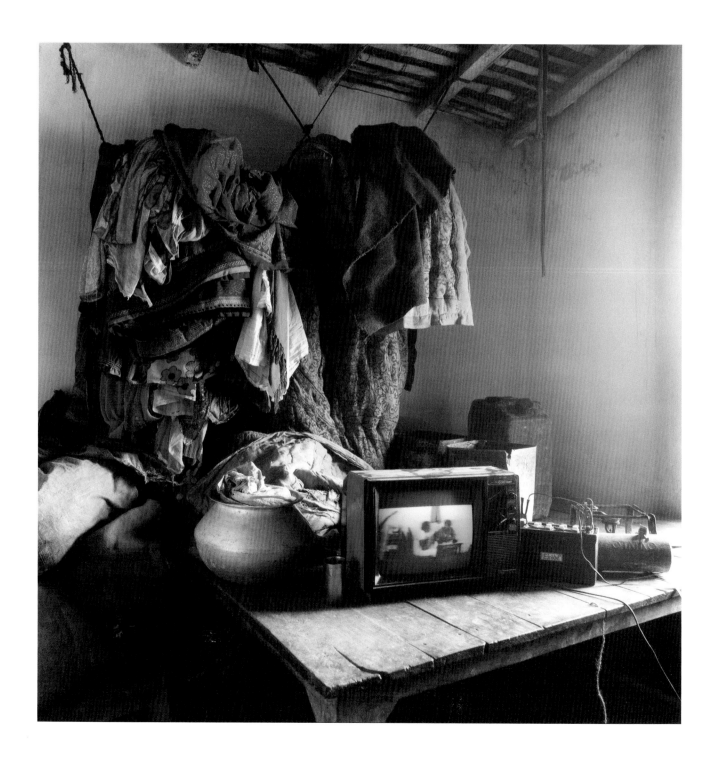

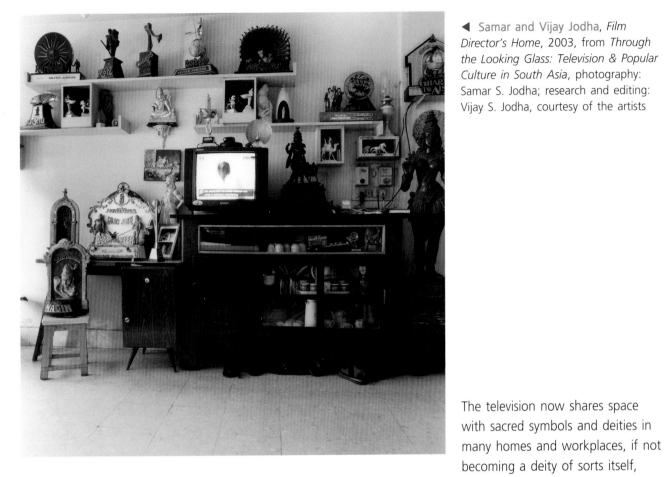

◀ Samar and Vijay Jodha, *Film Director's Home*, 2003, from *Through the Looking Glass: Television & Popular Culture in South Asia*, photography: Samar S. Jodha; research and editing: Vijay S. Jodha, courtesy of the artists

The television now shares space with sacred symbols and deities in many homes and workplaces, if not becoming a deity of sorts itself, commanding all eyes, ears and even furniture. Placed under words of solace in a hospital, ahead of portraits of dead ancestors in a hotel reception or among the inventory in a hardware store, television is omnipresent. The manner of its display conveys unintended tales about its relationship to its owners, their aspirations, their life-world and a social history to which it has borne witness. Television becomes more than an artifact, it is transformed to a window into a society.

– Samar and Vijay Jodha [13]

◀ Samar and Vijay Jodha, *Farmer's Home*, 2003, from *Through the Looking Glass: Television & Popular Culture in South Asia*, photography: Samar S. Jodha; research and editing: Vijay S. Jodha, courtesy of the artists

Pushpamala N.

Rashtriy Kheer & Desiy Salad (National Pudding and Indigenous Salad) is a whimsical commentary on an ideal Indian family in the first decade after independence. Using passages from her mother and mother-in-law's old recipe and scrapbooks, the artist (who plays the pregnant mother), highlights prescribed familial and gender roles. The title of the work refers to patriotic recipes based on the colors of the Indian flag.

 – Paul Sternberger
 (for this volume)

◄◄▼ Pushpamala N., *Rashtriy Kheer & Desiy Salad (National Pudding and Indigenous Salad)*, 2004, experimental short film, 11:00, courtesy of Bose Pacia Gallery, New York, and artist

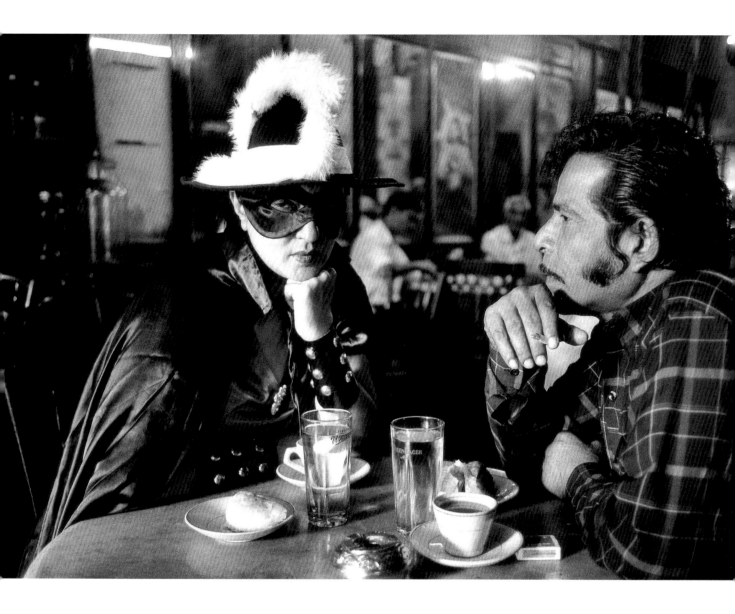

Phantom Lady or Kismet is a photo-romance set in Bombay, about a masked adventurer and her search for her lost twin sister separated in childhood, who has now become a part of the underground mafia. It was shot like a thriller using real locations, with typical scenes and characters. Bombay has a place in the Indian imagination as the great modern metropolis, a place of great opportunities and freedom but also of decadence and cruelty. It was an homage to the city as a center of theatre and film, as the producer of modern fantasies. When I become the protagonist, I put myself into various kinds of narratives: one of them is my own story....

— Pushpamala N.[14]

◀▼ Pushpamala N., *Phantom Lady or Kismet: a photoromance*, 1996–8, series of 25 photographs, 16 x 20 inches, photography: Meenal Agarwal; actor: Vinay Patak as the Don, courtesy Shumita and Arani Bose Collection, New York

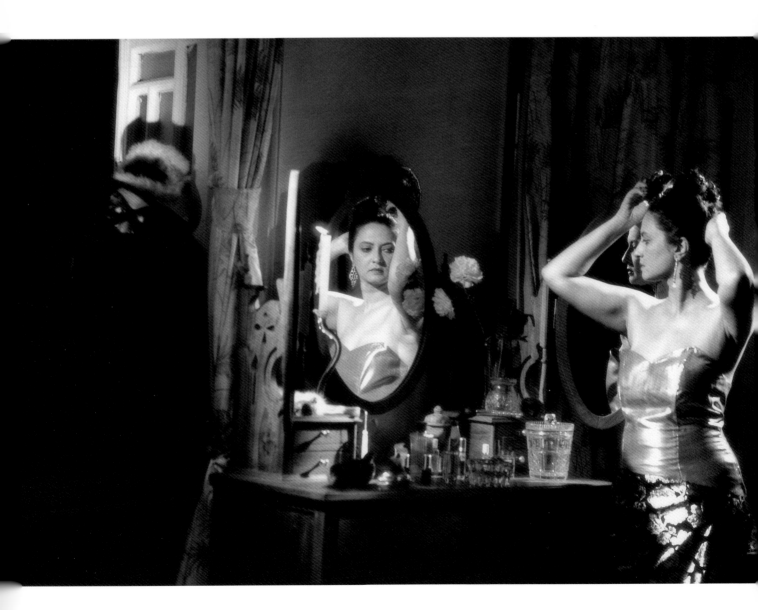

▼▶ Pushpamala N., *Phantom Lady or Kismet: a photoromance*, 1996–8, series of 25 photographs, 20 x 16 inches, photography: Meenal Agarwal; actor: Vinay Patak as the Don, courtesy Shumita and Arani Bose Collection, New York

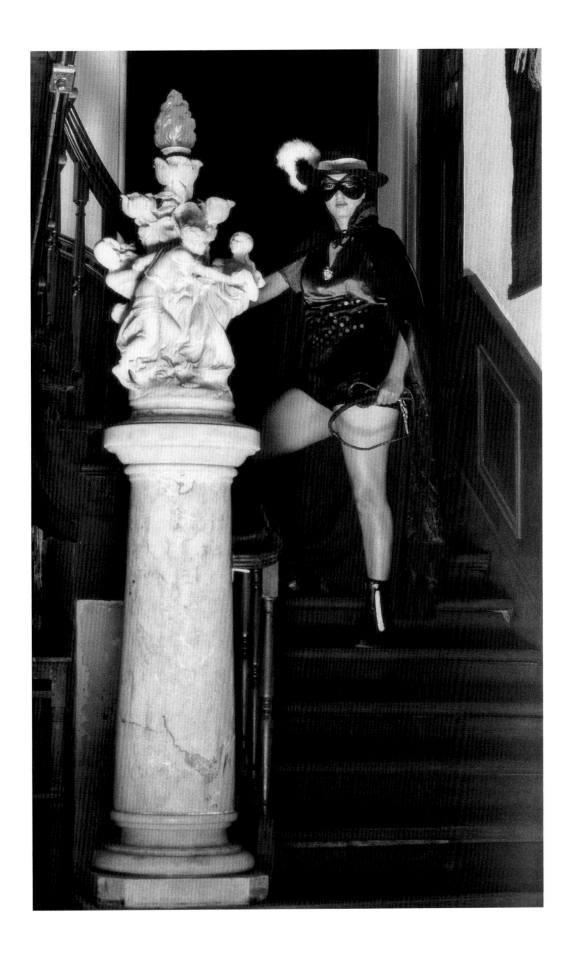

Jitish Kallat

Employing the 360 degrees
panoramic format, one is able to
hold multiple timeframes within a
single still image. For instance,
within the red brackets, a moving
taxi occupies the same spot where
a rickshaw stood moments ago,
mimicking a mishap. The two men
seen on either side of this crash are
the same; they have marched
across in the moments that passed.
 – Jitish Kallat [15]

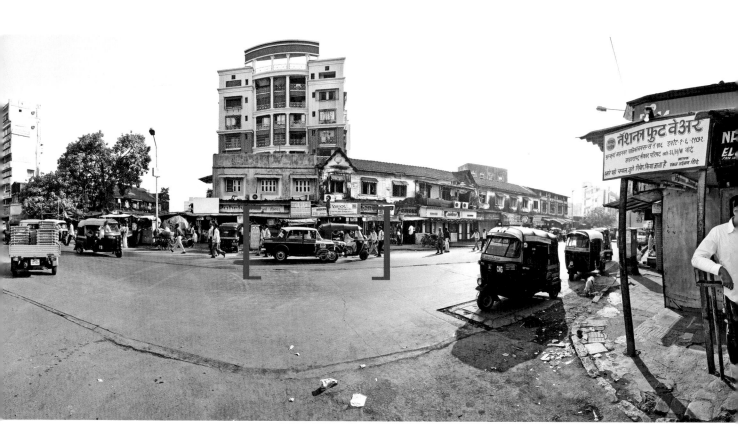

▼ Jitish Kallat, *Artist Making Local Call*, 2005, digital print on vinyl mesh, 95 x 411 inches, courtesy of the artist

Shantanu Lodh

In a postcolonial society…devoid of social welfare and financial security, the family plays a crucial role in providing conditioned support and the transfer of traditional values from one generation to the other either violently or casually. The mainstream culture is dedicated to the peace and unity of the all compromising Ideal Family which is of course disintegrating, where everybody love / hates everybody else in such a way that the traditional hierarchies of power remain intact.

The tea serving ceremony by the servant class (a unique phenomenon of the colonial period which has attained a household / domestic popularity) to the English Babu or the colonial master is a particular way of representing internalized colonial values and relationships. These constitute a large section of the modern Indian family, and are inherited from the colonial masters as ancestral property.

– Shantanu Lodh [16]

◀◀ Shantanu Lodh, *I Slapped My (Semi-Feudal, Semi-Colonial) Father*, 2001, series of 11 photographs, 20 x 14 inches each, courtesy of the artist

Anita Dube

▲▲▶ Anita Dube, *Kissa-e-Noor Mohammed (Garam Hawa)*, 2004, single-channel video, 15:00, courtesy of the artist

I attempt to transcend my gender,
class and religion through the
identity of Noor, my alter ego,
where fact and fiction collide,
where I speak to myself and of
myself, with the intention of
problematizing both performative
gestures within culture, as well as
activism.

– Anita Dube [17]

Tejal Shah

Male and female, where is
 the limit?
The beard as a macho
 statement.
Jewelry and make-up
 constructing the female.
Two masks that work as a
 cliché sign of gender for
 society.
What is happening when
 male and female cross
 these borders?
What is the limit of human
 sexuality?

In this work using video &
performance, we construct the
trans-formation, site, mutation,
figuration from one gender to its
opposite. We try to communicate
and make possible a reflection about
the exploration of the opposite
gender behavior as a possible affinity
for a human sexual being.
 – Tejal Shah [18]

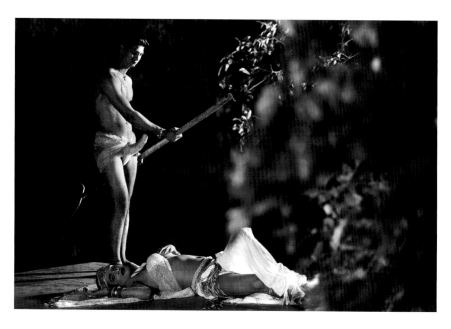

◄ Tejal Shah, *The Barge She Sat in,
Like a Burnished Throne / Burned on
the Water*, 2006, digital photograph on
archival photo paper, 38 x 57 ⅞ inches,
courtesy of Thomas Erben Gallery, New
York & Galerie Mirchandani +
Steinruecke, Mumbai, collection of the
artist

► Tejal Shah, *Southern Siren –
Maheshwari*, 2006, digital photograph
on archival alfa cellulose paper,
57 ⅞ x 38 inches, courtesy of Thomas
Erben Gallery, New York & Galerie
Mirchandani + Steinruecke, Mumbai,
collection of the artist

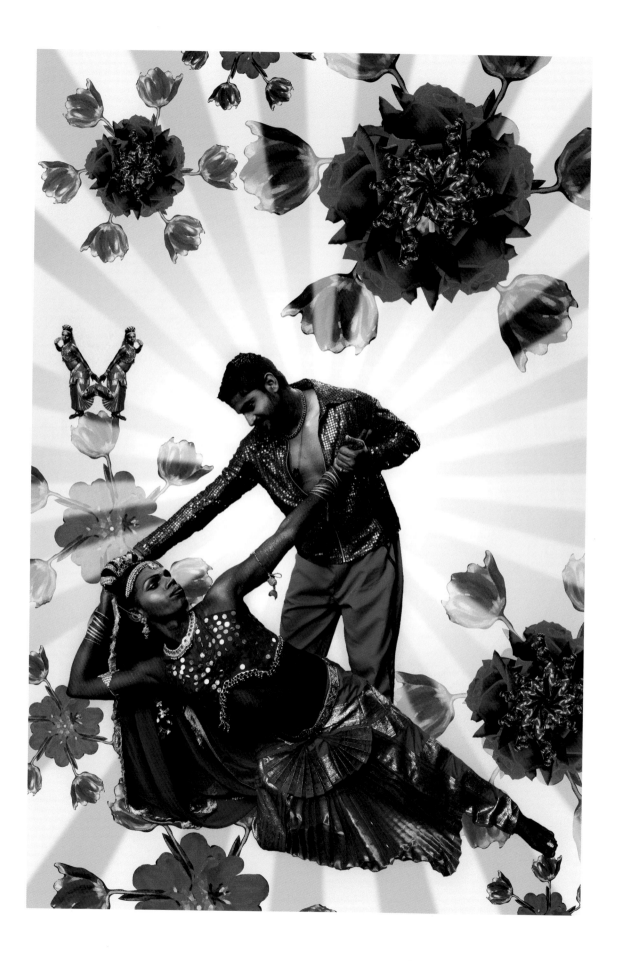

▼▶ Tejal Shah, *Trans-*, 2004–5,
composite stills from two-channel
video, 12:00, courtesy of Thomas Erben
Gallery, New York & Galerie
Mirchandani + Steinruecke, Mumbai,
collection of the artist

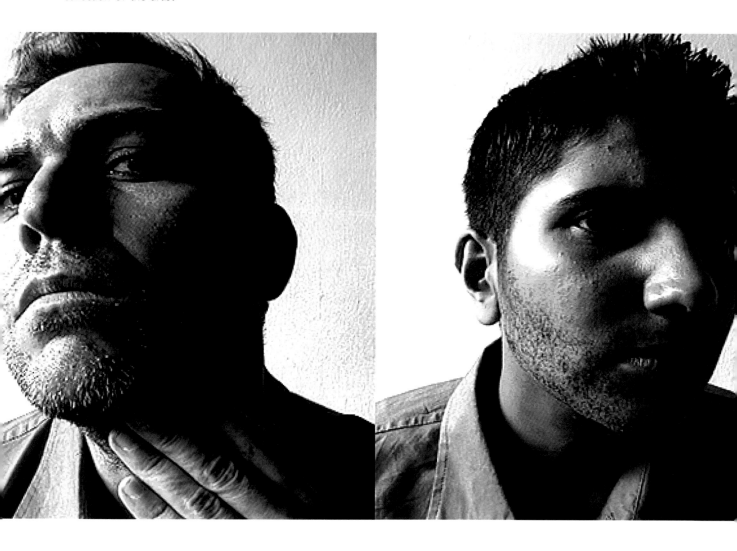

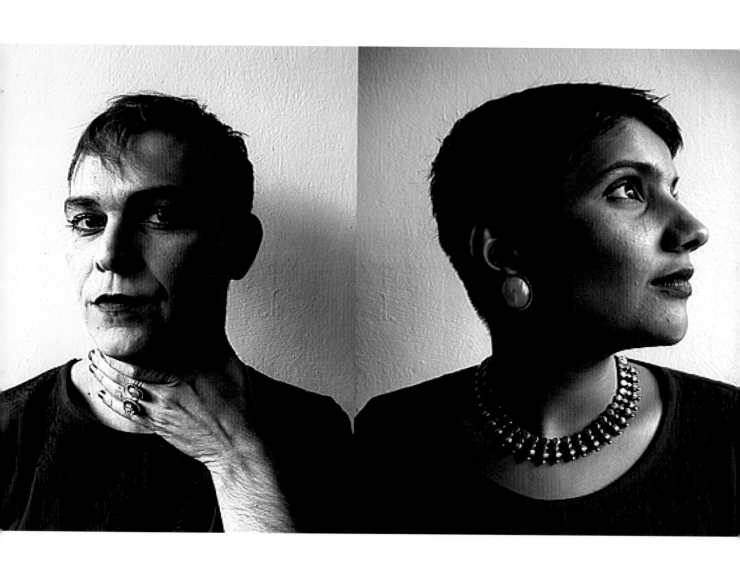

PLAYING INSIDE: PHOTOGRAPHY,

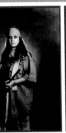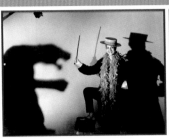

The exploration of the subjective world can be deadly serious or whimsical and playful. It can involve a self-reflexive appeal to both public and private histories. Shilpa Gupta's marching specters of global consumerism and militarism, Pushpamala N.'s take on ideals of womanhood enshrined in classical writing, and Gigi Scaria's philosophical navigation of the contemporary city explore the binary of sites of pleasure and fear. For Vivan Sundaram, an ancestral archive is vivified in a reconstructed family history. For Subodh Gupta, the transposition of traditional rural values onto an urban present becomes a physical enactment of political critique.

In the hands of some artists, photography and video can be less analytical and more expressive tools, distanced from cultural analysis and presenting instead personal and enigmatic systems of reference. This kind of subjective expressive output does not need to aspire to legibility, and often remains evocative and open-ended. Through the body as subject matter, the physical, the political, and the expressive meld in works by Sonia Khurana, Surekha and Anita Dube. In poetically visual pieces centered upon simple actions, Atul Bhalla and Ranbir Kaleka elevate the mundane to the philosophical.

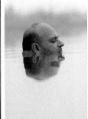
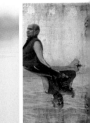

Pushpamala N.

Collaborating with a photo studio famous for its portraits of classic Bollywood stars, the artist dresses up as cinematic stereotypes of women to act out the nine essential human emotions from traditional Sanskrit *rasa*s: disgust (*bibhatsa*), wonder (*adbhuta*), love (*shringara*), fear (*bhayanaka*), tranquility (*shanta*), anger (*roudra*), courage (*veera*), laughter (*hasya*), and compassion (*karuna*).

– Paul Sternberger
(for this volume)

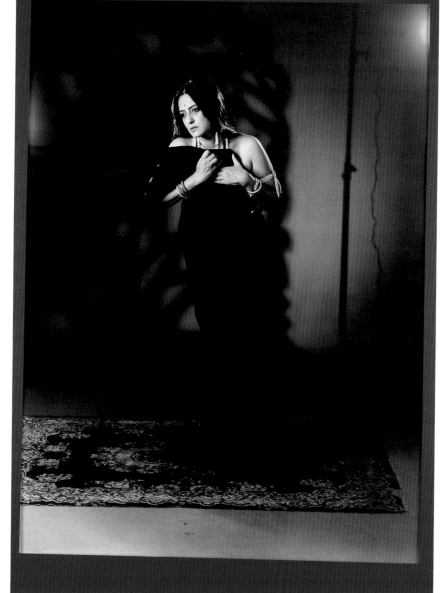

◀ Pushpamala N., *The Navarasa Suite*, 2000–3, set of nine sepia-toned black and white photographs, photography: J.H. Thakker and Vimal Thakker, India Photo Studio, Mumbai, courtesy Shumita and Arani Bose Collection, New York

▶ Pushpamala N., *Bibhatsa* [disgust], 2000–3, from *The Navarasa Suite*, set of nine sepia-toned black and white photographs, 26 x 20 inches, photography: J.H. Thakker and Vimal Thakker, India Photo Studio, Mumbai, courtesy Shumita and Arani Bose Collection, New York

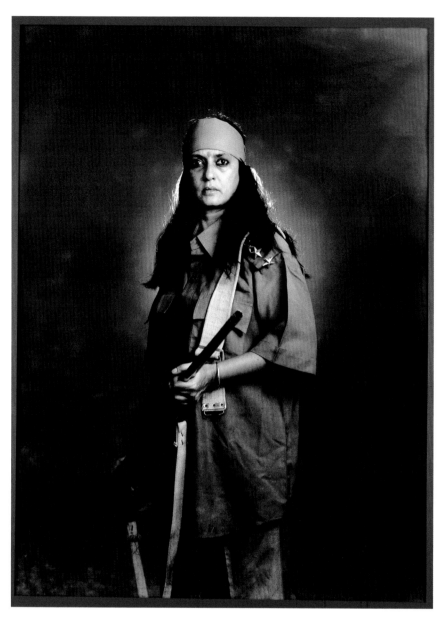

▲ Pushpamala N., *Veera* [courage], 2000–3, from *The Navarasa Suite*, set of nine sepia-toned black and white photographs, 26 x 20 inches, photography: J.H. Thakker and Vimal Thakker, India Photo Studio, Mumbai, courtesy Shumita and Arani Bose Collection, New York

▶ Pushpamala N., *Hasya* [laughter], 2000–3, *The Navarasa Suite*, set of nine sepia-toned black and white photographs, 20 x 26 inches, photography: J.H. Thakker and Vimal Thakker, India Photo Studio, Mumbai, courtesy Shumita and Arani Bose Collection, New York

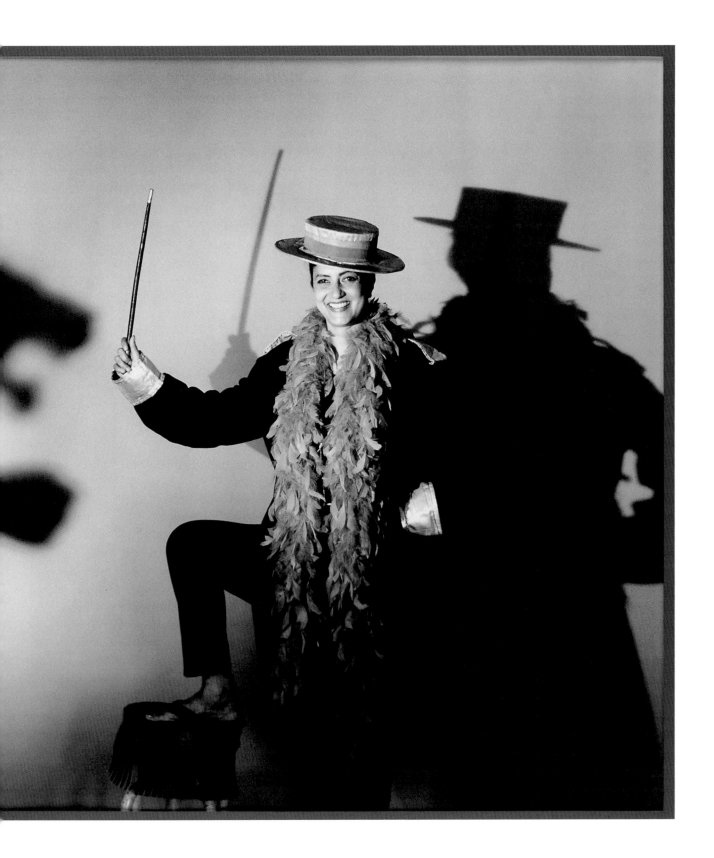

▼▶ Shilpa Gupta, *Untitled*, 2004,
interactive video projection with sound,
courtesy of the artist

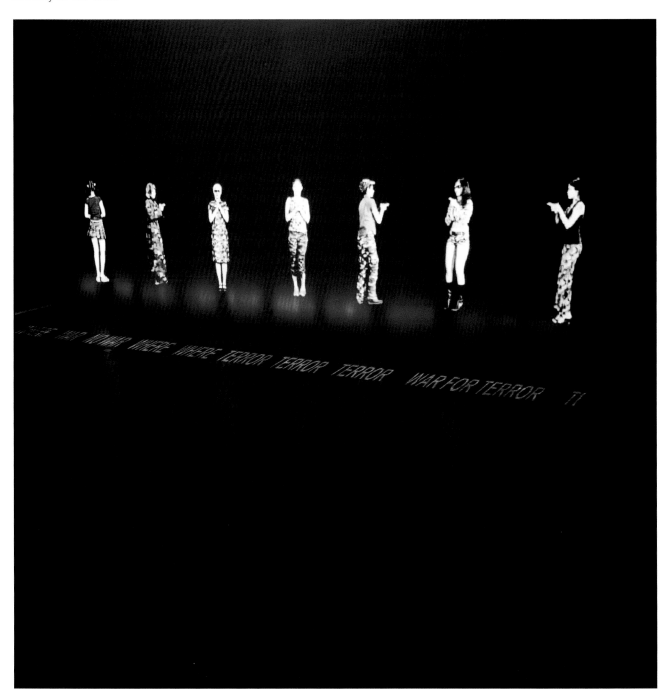

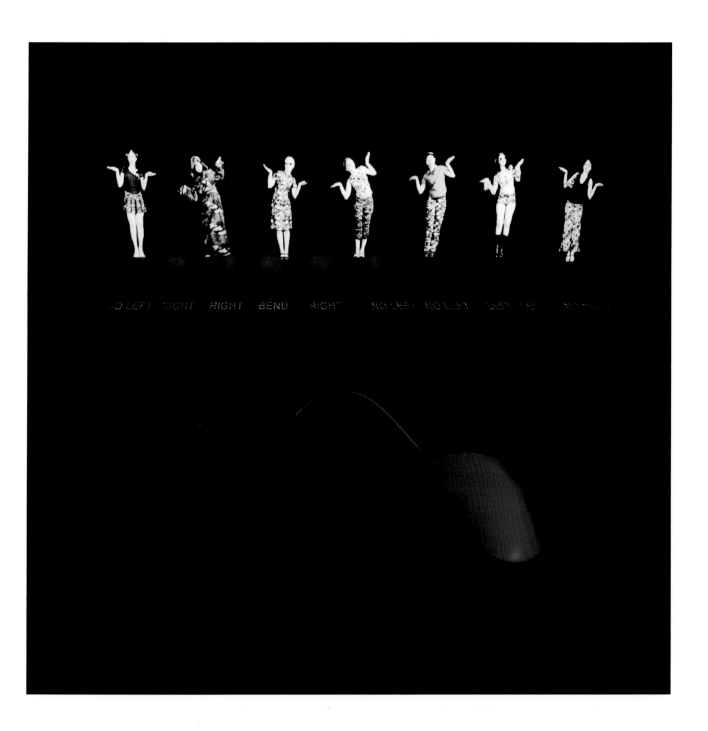

... in a capitalist society, we enjoy being programmed. We find instant satiation and loss of memory in turning ourselves into puppets. We allow media, electronic extensions of ourselves now in hands of a corporate often with state support nexus to think for us and amputate individual reasoning.... Mental and physical activity slips from the mechanical to the mindless, deteriorating into fear, chaos and violence, against an enemy that does not exist, in a world where global consent is hijacked to fight a war in search of weapons which were never there. Everybody Bend; Don't Talk, Don't See, Don't Hear. Gandhi said so.

– Shilpa Gupta [19]

Gigi Scaria

The Lost City deals with the existence of an individual in his vast urban surroundings. Losing memory, on the other hand, reminds us of the layers of information one has to carry out in a single day's business. The city tries to betray its own people by its ever-changing physical appearance. It appears to us as a constantly changing unattainable space, the city wages war against our collective consciousness.

– Gigi Scaria [20]

Vivan Sundaram

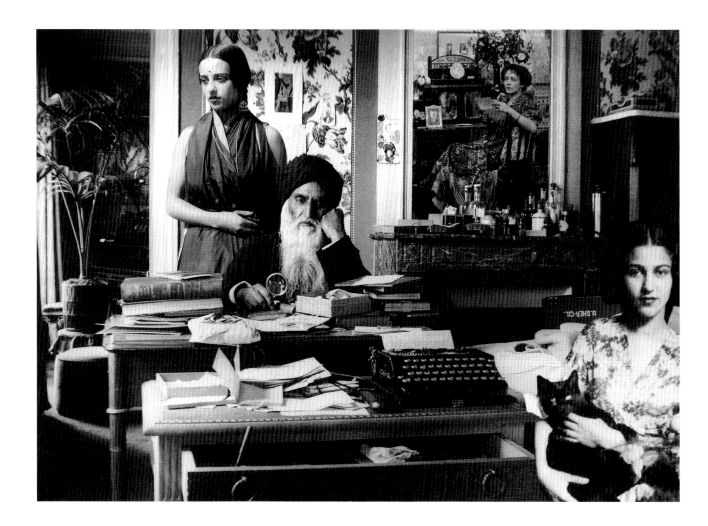

I will orchestrate the images with a digital wand half a century later. In excavating the photograph of the artist as a boy with a Voigtländer camera, I signal a provocative relationship. An artist using his family archive of photographs to make "future" works of art: what kind of "genetic" maneuver, what kind of narcissistic relay does this unwind?

— Vivan Sundaram [21]

◀ Vivan Sundaram, *Re-take of Amrita
– Remembering the Past, Looking to
the Future*, 2001, 15 x 21 inches,
courtesy of Sepia International

▼ Vivan Sundaram, *Re-take of Amrita
– Preening*, 2001, 15 x 21 inches,
courtesy of Sepia International

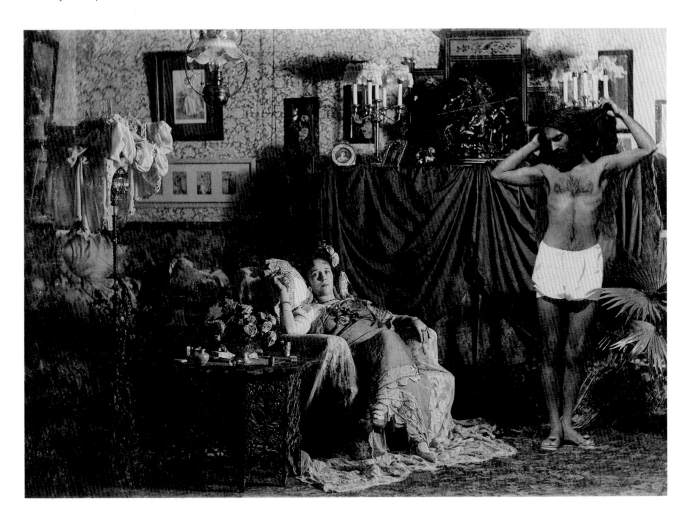

▼ Vivan Sundaram, *Re-take of Amrita – Bourgeois Family – Mirror Frieze*, 2001, 15 x 26 inches, courtesy of Sepia International

▶ Vivan Sundaram, *Re-take of Amrita – Sisters with "Two Girls"*, 2001, 15 x 12.2 inches, courtesy of Sepia International

Subodh Gupta

In India, cow dung has contradictory connotations: within spiritual belief it assumes the hallowed position of the cleanser / atoner; whilst on the other hand, its day to day associations are as waste element / defiler.

In *Pure*, I use my body as the subject and the object of a scene in which these contradictory notions of cow dung are ritualistically played out in an urban context.

 – Subodh Gupta [22]

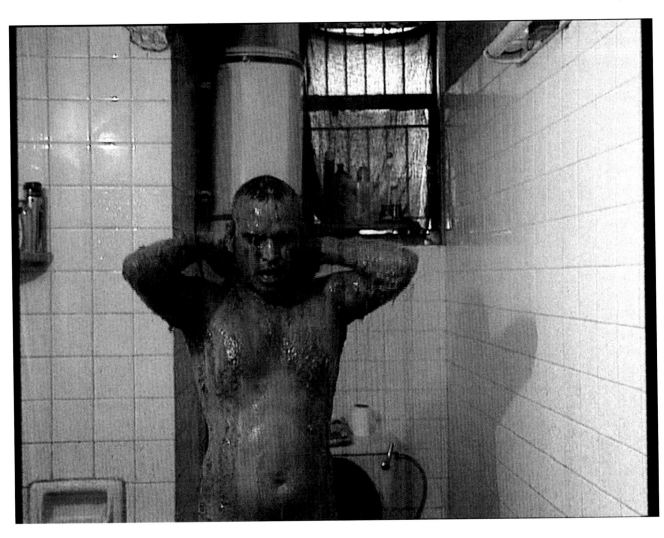

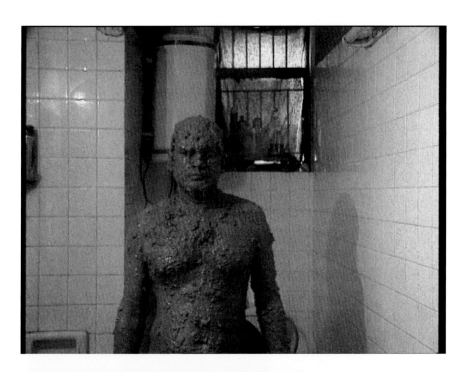

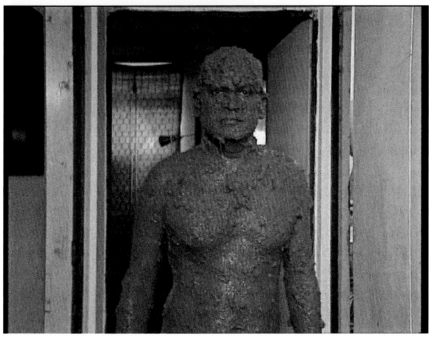

◀▲◀ Subodh Gupta, *Pure*, 2000, single-channel video, 8:00, courtesy of the artist

▶▼ Surekha, *The Other-Self*, 2005,
series of 6 digital photographs,
24 x 20 inches, courtesy of the artist

Surekha

A cautious but irresistible urge to
address the gender issue – through
visual media – has been a natural
part of [my] creative methodology.
[My works] explore the concept of
"body as a site of contestation and
appropriation" that existed in
locations / sites that share similar /
different histories. These address
the issue of redefining / relocating
feminine spaces, within a given
circumstance and discourse, private
or public. A creative tension lies
between private, subjective values
and social concerns.

– Surekha [23]

Sonia Khurana

I attempt to draw critically on
references to the social domain – to
the geo-political locale and to
cultural and gendered identity – in
ways that are often visually simple
and understated.

 Through deliberately poetic
intimations, I strive to persistently
explore and re-define the space of
the political.

— Sonia Khurana [24]

▼ Sonia Khurana, *Head-Hand*, 2004,
single-channel video, 7:30, courtesy of the
artist

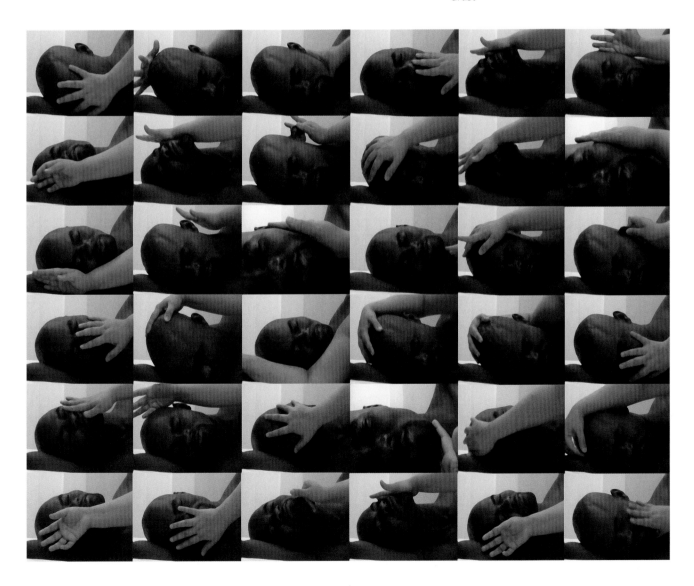

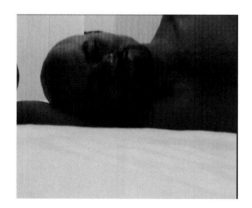 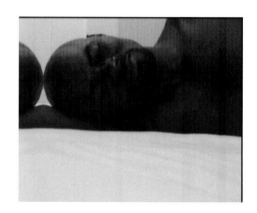

▲ Sonia Khurana, *Tantra*, 2004,
single-channel video installation, 0:44,
courtesy of the artist

Anita Dube

Although the starting point of my work is autobiographical and subjective, I'm concerned that none of this should lead to closure – a kind of self-referential psychological hole. So what starts internally as sensation and emotion, expands and returns to the objects and events in the world. That is where the work finds elucidation: in the threading of the subjective into its correspondence, where it begins to have another life, an art life.

<div align="right">

– Anita Dube [25]

</div>

▼▶▶ Anita Dube, *Via Negativa*, 2000, 3 gelatin silver prints, 30 x 44 inches each, photographs by C.K. Rajan, courtesy of the artist

Atul Bhalla

My work is an attempt to
 understand water.
How I perceive it, feel it, eat it,
 drink it, wash in it, bathe in it,
 swim, wade, sink or will drown
 in it.
How I drench, soak, douse,
 moisten, quench, dilute, dampen,
 cleanse or purify.
How I excrete tears, sweat or urine.
How it falls, drops, floods,
 inundates, levels, buoys, lashes,
 gushes, swells and ripples.
How it exists as fog, mist, cloud,
 steam, snow, sleet, rain or
 puddle.
How it contains or is contained.
How it is dammed or bottled.

– Atul Bhalla [26]

◄◄▶▶ Atul Bhalla, *I Was Not Waving But Drowning II*, 2005, series of 14 photographs, 18 x 12 inches each, courtesy of the artist

Ranbir Kaleka

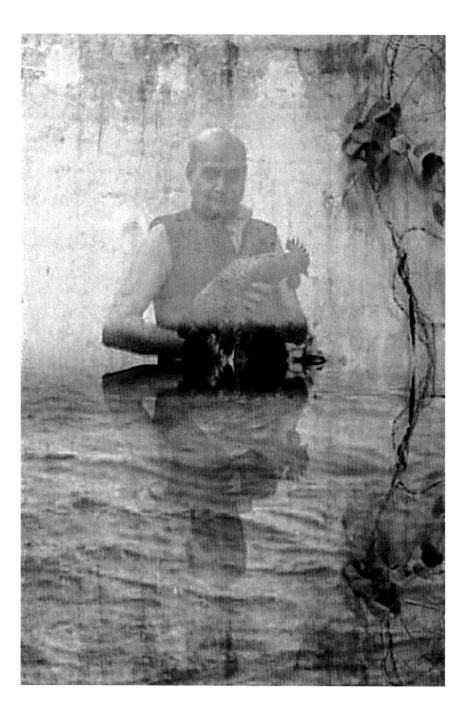

▶▶ Ranbir Kaleka, *Cockerel-2*, 2004, single-channel video installation, 6:00, actor: Ram Gopal Bajaj; cockerel: Mustapha; digital compositing and video stills: Riverbank Studios, New Delhi, courtesy of the artist

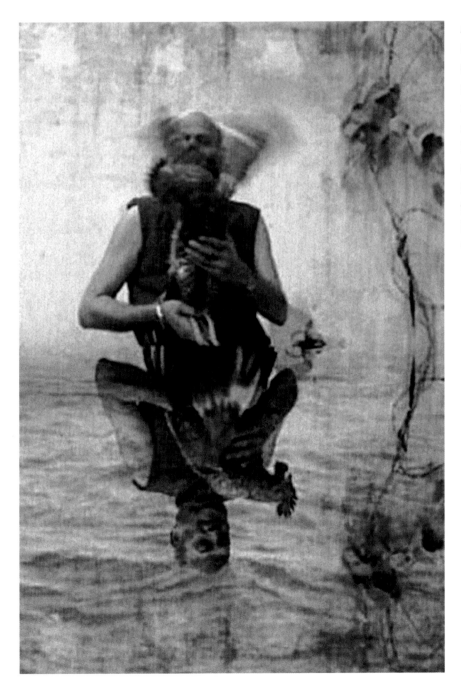

A man is caught in a circle of endless pursuit and capture of his escaped "cockerel." The viewer's reverie is jolted by a play with diegetic and non-diegetic conventions of sound: domestic, industrial, everyday and the environmental. The only relief is the long silent lapping of the waves on the empty screen at the end of the loop before the man again finds his "cockerel" and enters the frame.

– Ranbir Kaleka [27]

▼▶ Ranbir Kaleka, *Cockerel-2*, 2004,
single-channel video installation,
6:00, actor: Ram Gopal Bajaj; cockerel:
Mustapha; digital compositing and
video stills: Riverbank Studios,
New Delhi, courtesy of the artist

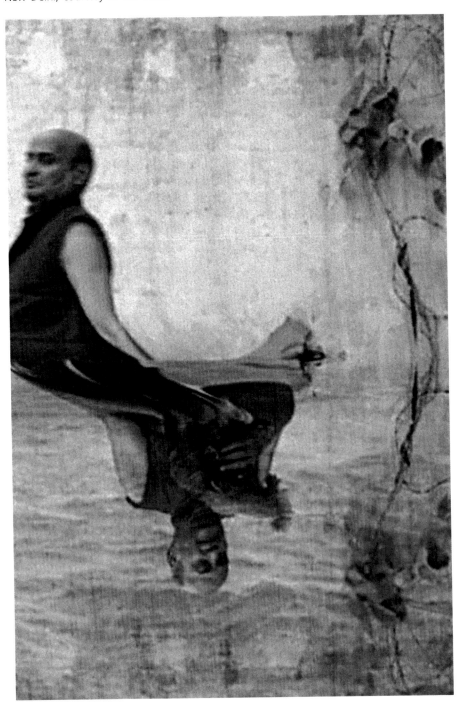

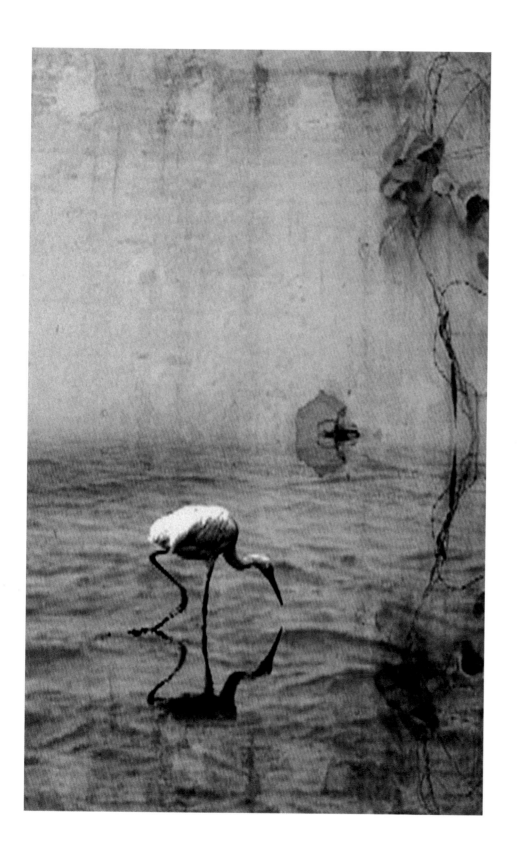

WHERE IS THE BORDER? T:

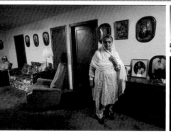 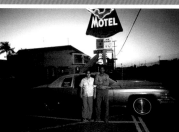 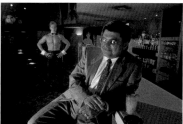

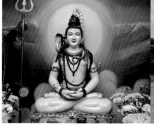 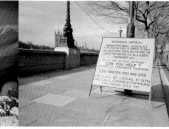

Photographers have used varied means to examine cross-cultural experiences in India and abroad. These strategies include relatively straightforward photo essays such as those of Pablo Bartholomew and Gauri Gill, in which the reconciliation of competing cultural traditions and values mirror Indian experience abroad. Preferring to construct and perform rather than find and record, Annu Palakunnathu Matthew uses performative self-portraiture as a way of deconstructing national and racial identity. In contrast, Sunil Gupta explores deeply private realms of interpersonal relationships, sexuality and AIDS, while also considering a subjective diasporic identity. As a whole, the work of these artists moves through post-colonial commentary to an engagement with tradition and sets up a dialogue with entrenched values and shifting identities.

Pablo Bartholomew

[In *Emigrés*, I] examine the two worlds of the migrant Indian – the inner world which he brought within himself; the world of roots, religion, of tradition – of "Indianness" – and to see how much of it was retained and preserved in the exterior world – the world he or she currently lives in. What is the relationship between the two? How does one world manifest itself in the other? What are the relationships, adjustments, juxtapositions of signs and images that might explain the truth between the two worlds? It has not been my intention to project only the "Who's Who" of Indian success stories, nor just a profile of those who have made good. Because for those handful who have struck gold, there are thousands who struggle and strive in pursuit of their dreams. The project is to be able to counterpoise the struggle with the success, the humor with the irony; to look at rites and rituals in everyday life such as births, marriages, death, and community and religious occasions in the context of their shifting cultural and physical landscapes.

– Pablo Bartholomew [28]

▶ Pablo Bartholomew, *Nand Kaur, with her Son, an ex-WWII Pilot, Yuba City*, 1987, from the series *Emigrés*, 11 x 14 inches, courtesy of the artist

▼ Pablo Bartholomew, *A Motel Owner and his Wife, Fresno*, 1987, from the series *Emigrés*, 11 x 14 inches, courtesy of the artist

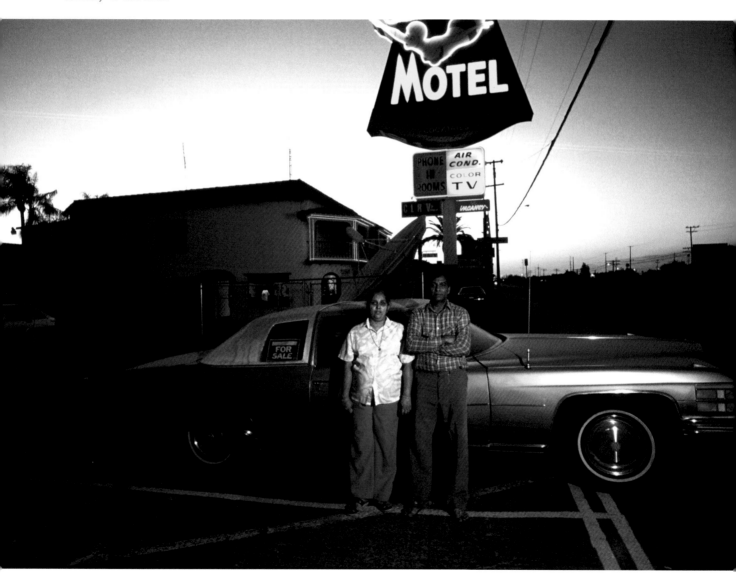

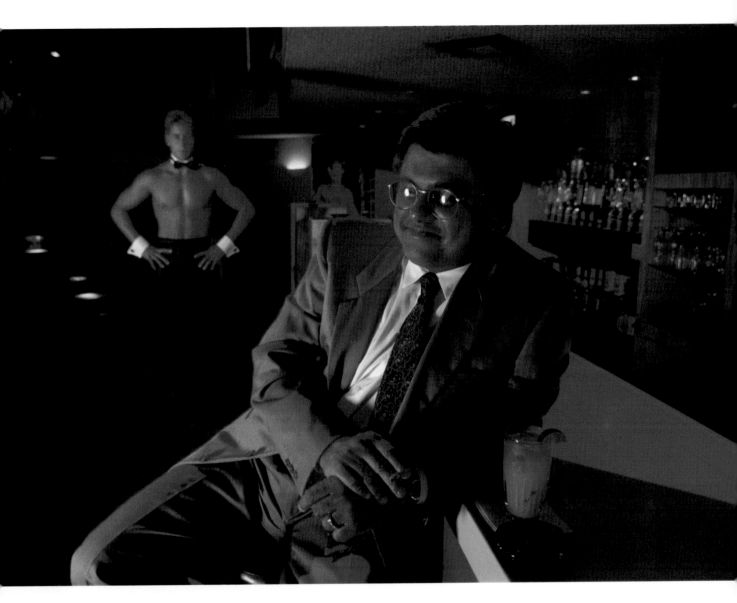

▲ Pablo Bartholomew, *Steve Banerji, Owner of Chippendales at his LA Operation*, 1987, from the series *Emigrés*, 11 x 14 inches, courtesy of the artist

Gauri Gill

I wished to make portraits of individuals – the taxi driver and shopkeeper and IT professional, also the magician, NYPD officer, DJ, rapper, farmer, drag queen, pharmacist, gas station attendant…remarkable people that may have their roots in one particular community, but represent only themselves. In that they are as American as anyone else. I hope my work shows some of the details and dramas of daily life, how individuals navigate their circumstances, and selves, in a new country. How does one adapt and yet retain one's soul? Can one – where is the resistance? Is this one's place after all, or is one perennially out of place.

– Gauri Gill [29]

▶ Gauri Gill, *Party for Indian Entrepreneurs, Washington DC*, 2002, from the series *The Americans*, 16 x 24 inches, courtesy of the artist

▼► Gauri Gill, *Wedding of Dr. Suresh Gupta's Son, Virginia*, 2002, from the series *The Americans*, 12 x 36 inches, courtesy of the artist

Annu Palakunnathu Matthew

NOBLE SAVAGE

Photograph by E.S. Curtis

SAVAGE NOBLE

Photograph by A.P. Matthew

As an immigrant, I am often questioned about where I am "really from." ...In this portfolio, I look at the other "Indian." The way nineteenth-century photographers of Native Americans looked at what they called the primitive natives is similar to the colonial gaze of the nineteenth-century British photographers working in India. In every culture there is the "other."

In this portfolio I play on my own "otherness," using photographs of Native Americans from the nineteenth century that perpetuate and reinforce stereotypes. The images highlight assimilation, use labels and make many assumptions. ...I challenge the viewers' assumptions of then and now, us and them, exotic and local.

— Annu Palakunnathu Matthew [30]

◄ Annu Palakunnathu Matthew,
Noble Savage / Savage Noble, 2001,
from *An Indian from India*, archival
digital print, 12 x 16 inches, [On left
Two Moons – Cheyenne by Edward S.
Curtis, courtesy Northwestern University
Library, Evanston, Illinois], courtesy of
Sepia International

RED INDIAN

Photograph by E.S. Curtis

BROWN INDIAN

Photograph by A.P. Matthew

▲ Annu Palakunnathu Matthew,
Red Indian / Brown Indian, 2001, from
An Indian from India, archival digital
print, 12 x 16 inches, [On left *Alchise,
Apache Indian, half-length portrait, left
profile* by Edward S. Curtis, courtesy The
Library of Congress, Washington DC],
courtesy of Sepia International

Sunil Gupta

Exiles. Yes, that's what I called my photo art project in the 1980s that took a close personal look at gay life in Delhi. Well, what passed for gay life, at any rate. It wasn't a very happy scene. A few like me found ourselves outside the country and chose to remain there. Those that were here made the best of it by remaining as silent and invisible as possible.

At the turn of the Millennium the news from Delhi became more

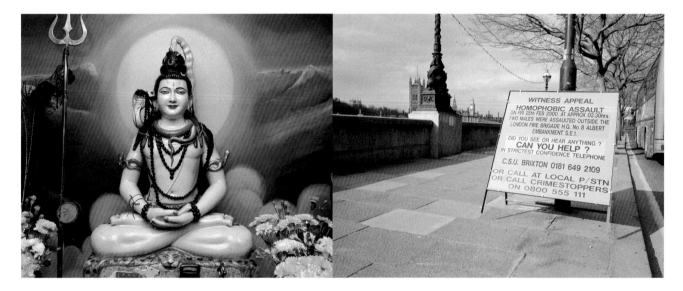

positive. Gay life was making itself felt and things were getting better. …I made another body of work seeking to locate the geography of homelands. There was Canada, where my parents had migrated to, there was New York, where I had gone to finally escape from them, then there was London, what seemed like my final resting place. But, inescapably there was Delhi.

– Sunil Gupta [31]

◄ Sunil Gupta, *Queens, New York /
Albert Embankment, London*, 2001 / 3,
from the series *Homelands*, 59 x 25 ½
inches, courtesy of the artist

▲ Sunil Gupta, *Washing / Disabled*,
2006, from the series *Country – Portrait
of an Indian Family*, 59 x 25 ½ inches,
courtesy of the artist

▼ Sunil Gupta, *Gun / Wheat*, 2006,
from the series *Country – Portrait of
an Indian Family*, 59 x 25 ½ inches,
courtesy of the artist

▲ Sunil Gupta, *Love & Light #1*, 2004,
59 x 25½ inches, courtesy of the artist

NOTES

[1] Michael E. Hoffman, *Raghu Rai's India – A Retrospective* (Tokyo: The Bunkamura Museum of Art, 2001), p. 13.

[2] Excerpt from Manish Swarup, Artist's Statement, www.manishswarup.com.

[3] Excerpt from Manish Swarup, Artist's Statement, www.manishswarup.com.

[4] John Baldessari, Introduction to Raghubir Singh, *A Way Into India* (New York: Phaidon Press, 2002).

[5] Gayatri Sinha, *Middle Age Spread: Imaging India, 1947–2004* (New Delhi: Anant, 2004), p. 20.

[6] Excerpt from Ravi Agarwal, unpublished Artist's Notes.

[7] Excerpt from Ravi Agarwal, unpublished Artist's Notes.

[8] Paraphrased from Gayatri Sinha, "A Life Away from Life," *The Hindu*, October 28, 2005.

[9] Excerpt from Gigi Scaria, Artist's Statement, www.gigiscaria.com.

[10] Excerpt from transcript of Surekha, *Tree Woman*, 2005, single-channel video.

[11] Ashish Rajadhyaksha and Paul Willemen, *Encyclopedia of Indian Cinema* (London: BFI Publishing, 1999), p. 10.

[12] Excerpt from Rajesh Vora, unpublished Artist's Statement.

[13] Excerpt from Samar and Vijay Jodha, Introduction to *Through the Looking Glass: Television & Popular Culture in South Asia*, 2003.

[14] Excerpt from Pushpamala N., Artist's Statement, www.gallerychemould.com/pushp_bio.htm.

[15] Excerpt from Jitish Kallat, unpublished Artist's Statement.

[16] Excerpt from Shantanu Lodh, unpublished Artist's Statement.

[17] Quoted in Laiq Qureshi, "Her Lenses Hold, Paint the Mind. Photography Exhibition by Anita Dube," bombayartgallery.com, November 9, 2005.

[18] Excerpt from Tejal Shah, Artist's Statement, www.tejals.com.

[19] Excerpt from Shilpa Gupta, Artist's Statement, www.flyinthe.net.

[20] Excerpt from Gigi Scaria, Artist's Statement, www.gigiscaria.com.

[21] *Vivan Sundaram: Re-take of Amrita* (New York: Sepia International and the Alkazi Collection, 2006), p. 9.

[22] Subodh Gupta in *Video Art in India* (Calcutta: Apeejay Press, 2003), p. 76.

[23] Excerpt from Surekha, unpublished Artist's Statement.

[24] Excerpt from Sonia Khurana, unpublished Artist's Statement.

[25] Quoted in Kamala Kapoor, "Sieve-O-Physis: An interview with Anita Dube," *Anita Dube* (New York: Bose Pacia, 2005).

[26] Excerpt from Atul Bhalla, unpublished Artist's Note.

[27] *Ranbir Kaleka: Crossings* (New York: Bose Pacia, 2005), p. 28.

[28] Excerpt from Pablo Bartholomew, Press Release, c. 1994.

[29] Excerpt from Gauri Gill, unpublished Artist's Note.

[30] Excerpt from Annu Palakunnathu Matthew, Artist's Statement, www.annumatthew.com.

[31] Excerpt from Sunil Gupta, "A Return from Exile," www.sunilgupta.net, May 17, 2006.

Checklist of Works

RAVI AGARWAL

Boat from the series *Alien Waters*, 2004–6, 11 x 16 inches, courtesy of the artist

Interior from the series *Alien Waters*, 2004–6, 11 x 16 inches, courtesy of the artist

Refuse from the series *Alien Waters*, 2004–6, 11 x 16 inches, courtesy of the artist

Kite String Making, Surat, Gujarat, 1998, from the series *Down and Out: Migrant Labor in Gujarat*, 11 x 16 inches, courtesy of the artist

Printing of Cloth, Surat, Gujarat, 1998, from the series *Down and Out: Migrant Labor in Gujarat*, 11 x 16 inches, courtesy of the artist

Roadside Cobbler, Surat, Gujarat, 1998, from the series *Down and Out: Migrant Labor in Gujarat*, 11 x 16 inches, courtesy of the artist

See pages 64–7

NAVJOT ALTAF

Lacuna in Testimony, 2003, three-channel video installation with 72 mirrors, time variable, courtesy of the artist

See pages 72–5

PABLO BARTHOLOMEW

A Motel Owner and his Wife, Fresno, 1987, from the series *Emigrés*, 11 x 14 inches, courtesy of the artist

Dr. Kumar Patel at Bell Labs in New Jersey, Fresno, 1987, from the series *Emigrés*, 11 x 14 inches, courtesy of the artist

Last Viewing of a Punjabi Woman in a Funeral Parlor, El Centro, USA, 1987, from the series *Emigrés*, 11 x 14 inches, courtesy of the artist

Nand Kaur, with her Son, an ex-WWII Pilot, Yuba City, 1987, from the series *Emigrés*, 11 x 14 inches, courtesy of the artist

One of the Many Patel Motels, Fresno, 1987, from the series *Emigrés*, 11 x 14 inches, courtesy of the artist

Steve Banerji, Owner of Chippendales at his LA Operation, 1987, from the series *Emigrés*, 11 x 14 inches, courtesy of the artist

See pages 134–7

ATUL BHALLA

I Was Not Waving But Drowning II, 2005, series of 14 photographs, 18 x 12 inches each, courtesy of the artist

See pages 124–7

SHAHID DATAWALA

Ladies Toilet, 2003, 30 x 22 inches, copyright Shahid Datawala, courtesy Tasveer / Foss-Gandi

Layered Arch, 2003, 30 x 22 inches, copyright Shahid Datawala, courtesy Tasveer / Foss-Gandi

Purdah Ladies, 2003, 30 x 22 inches, copyright Shahid Datawala, courtesy Tasveer / Foss-Gandi

Regal Man, 2003, 30 x 22 inches, copyright Shahid Datawala, courtesy Tasveer / Foss-Gandi

See pages 78–81

ANITA DUBE

Kissa-e-Noor Mohammed (Garam Hawa), 2004, single-channel video, 15:00, courtesy of the artist

Via Negativa, 2000, 3 gelatin silver prints, 30 x 44 inches each, photographs by C.K. Rajan, courtesy of the artist

See pages 96–7, 122–3

GAURI GILL

Birthday Party, Virginia, 2002, from the series *The Americans*, 12 x 36 inches, courtesy of the artist

Jagdeepak Steven Sandhu's Mother and Wife, Outside their Home, Virginia, 2002, from the series *The Americans*, 16 x 24 inches, courtesy of the artist

Motel Owner Dhansukh Dan Patel's Parents, in his New Home, Nashville, Tennessee,

2004, from the series *The Americans*, 12 x 36 inches, courtesy of the artist
Party for Indian Entrepreneurs, Washington DC, 2002, from the series *The Americans*, 16 x 24 inches, courtesy of the artist
Preparing for the Rath Yatra, Ganesha Temple, Nashville, Tennessee, 2004, from the series *The Americans*, 16 x 24 inches, courtesy of the artist
Wedding of Dr. Suresh Gupta's Son, Virginia, 2002, from the series *The Americans*, 12 x 36 inches, courtesy of the artist
See pages 138–41

SHILPA GUPTA

Untitled, 2004, interactive video projection with sound, courtesy of the artist
See pages 108–9

SUBODH GUPTA

Pure, 2000, single-channel video, 8:00, courtesy of the artist
See pages 116–7

SUNIL GUPTA

Foundation / Sunil, 2006, from the series *Country – Portrait of an Indian Family*, 59 x 25½ inches, courtesy of the artist
Gun / Wheat, 2006, from the series *Country – Portrait of an Indian Family*, 59 x 25½ inches, courtesy of the artist
Havan / House, 2006, from the series *Country – Portrait of an Indian Family*, 59 x 25½ inches, courtesy of the artist
Holi / Freedom Fighters, 2006, from the series *Country – Portrait of an Indian Family*, 59 x 25½ inches, courtesy of the artist
Love & Light #1, 2004, 59 x 25½ inches, courtesy of the artist
Mundia Pumar, Uttar Pradesh / Chesapeake Bay, Maryland, 2001 / 03, from the series *Homelands*, 59 x 25½ inches, courtesy of the artist
Queens, New York / Albert Embankment, London, 2001 / 3, from the series *Homelands*, 59 x 25½ inches, courtesy of the artist
Washing / Disabled, 2006, from the series *Country – Portrait of an Indian Family*, 59 x 25½ inches, courtesy of the artist
See pages 144–7

SAMAR AND VIJAY JODHA

Through the Looking Glass: Television & Popular Culture in South Asia, 2003, 20 digitally projected photographs, photography: Samar S. Jodha; research and editing: Vijay S. Jodha, courtesy of the artists
See pages 84–5

RANBIR KALEKA

Cockerel-2, 2004, single-channel video installation, 6:00, actor: Ram Gopal Bajaj; cockerel: Mustapha; digital compositing and video stills: Riverbank Studios, New Delhi, courtesy of the artist
See pages 128–31

JITISH KALLAT

Artist Making Local Call, 2005, digital print on vinyl mesh, 95 x 411 inches, courtesy of the artist
See pages 92–3

SONIA KHURANA

Head-Hand, 2004, single-channel video, 7:30, courtesy of the artist
Tantra, 2004, single-channel video installation, 0:44, courtesy of the artist
See pages 119–21

SHANTANU LODH

I Slapped My (Semi-Feudal, Semi-Colonial) Father, 2001, series of 11 photographs, 20 x 14 inches each, courtesy of the artist
See pages 94–5

ANNU PALAKUNNATHU MATTHEW

Noble Savage / Savage Noble, 2001, from *An Indian from India*, archival digital print, 12 x 16 inches, courtesy of Sepia International
Quanah Parker, Washington, DC / Annu Palakunnathu Matthew, Providence, RI [Before], 2000,

from *An Indian from India*,
archival digital print, 12 x 16
inches, courtesy of Sepia
International

*Quanah Parker, Washington, DC /
Annu Palakunnathu Matthew,
Providence, RI [After]*, 2000,
from *An Indian from India*,
archival digital print, 12 x 16
inches, courtesy of Sepia
International

Red Indian / Brown Indian, 2001,
from *An Indian from India*,
archival digital print, 12 x 16
inches, courtesy of Sepia
International
See pages 142–3

Pushpamala N.

*Phantom Lady or Kismet: a
photoromance*, 1996–8, series
of 25 photographs, 16 x 20
inches, photography: Meenal
Agarwal; actor: Vinay Patak as
the Don, courtesy Shumita and
Arani Bose Collection, New
York

*Rashtriy Kheer & Desiy Salad
(National Pudding and
Indigenous Salad)*, 2004,
experimental short film, 11:00,
courtesy of Bose Pacia Gallery,
New York, and artist

The Navarasa Suite, 2000–3, set
of nine sepia-toned black and
white photographs, 26 x 20
inches, photography: J.H.
Thakker and Vimal Thakker,
India Photo Studio, Mumbai,
courtesy Shumita and Arani
Bose Collection, New York
See pages 86–91, 104–7

Ram Rahman

Capital Studios, Delhi, 1986, 16 x
20 inches, courtesy of the
artist

Gents Urinal, Old Delhi, 1991,
20 x 16 inches, courtesy of the
artist

Hyderabad, 1982–3, 16 x 20
inches, courtesy of the artist

Indira Gandhi, Delhi, 1989,
20 x 16 inches, courtesy of the
artist

MF Husain Paints a Horse, Delhi,
1994, 16 x 20 inches, courtesy
of the artist

Narasimha Rao, Old Delhi, 1996,
20 x 16 inches, courtesy of the
artist
See pages 62–3

Raghu Rai

*Army Generals Preparing for Indira
Gandhi's Funeral, Delhi*, 1984,
20 x 24 inches, courtesy of the
artist

*Crowds Crashing into Teen Murti
House to Take a Last Look at
Indira Gandhi*, 1984, 20 x 24
inches, courtesy of the artist

Indira Gandhi at her Residence,
1984, 20 x 24 inches, courtesy
of the artist

*Indira Gandhi in Congress
Meeting, Delhi*, 1966, 20 x 24
inches, courtesy of the artist

Indira Gandhi, 1968, 20 x 24
inches, courtesy of the artist

*Mrs. Gandhi with the then
President Mr. V.V. Giri*, 1974,
20 x 24 inches, courtesy of the
artist

Rajiv Gandhi at the Funeral Pyre

of his Mother, Indira Gandhi,
1984, 20 x 24 inches, courtesy
of the artist

*Widows of Sikh Riots Following
the Death of Indira Gandhi*,
1984, 20 x 24 inches, courtesy
of the artist
See pages 52–4

Gigi Scaria

A Day with Sohail and Mariyan,
2004, single-channel video,
17:00, actors: Sohail Ali and
Mariyan Husain, courtesy of
the artist

The Lost City, 2005, single-
channel video, 14:00, actors:
Praveen Thambi and Ashwani
Kumar Ashu; voice: Sohail
Hashmi, courtesy of the artist
See pages 69, 110–1

Tejal Shah

Southern Siren – Maheshwari,
2006, digital photograph on
archival alfa cellulose paper,
57⅞ x 38 inches, courtesy of
Thomas Erben Gallery, New
York & Galerie Mirchandani +
Steinruecke, Mumbai,
collection of the artist

*The Barge She Sat in, Like a
Burnished Throne / Burned on
the Water*, 2006, digital
photograph on archival photo
paper, 38 x 57⅞ inches,
courtesy of Thomas Erben
Gallery, New York & Galerie
Mirchandani + Steinruecke,
Mumbai, collection of the artist

Trans-, 2004–5, two-channel

video, 12:00, courtesy of Thomas Erben Gallery, New York & Galerie Mirchandani + Steinruecke, Mumbai, collection of the artist

You Too Can Touch The Moon – Yashoda with Krishna, 2006, digital photograph on archival photo paper, 57 ⅞ x 38 inches, courtesy of Thomas Erben Gallery, New York & Galerie Mirchandani + Steinruecke, Mumbai, collection of the artist

See pages 98–101

RAGHUBIR SINGH

Kemp's Corner from a Leather Goods Shop, Mumbai, Maharashtra, 1989, 36 x 60 inches, © Succession Raghubir Singh

Pavement Mirror Shop, Howrah, West Bengal, 1991, 36 x 60 inches, © Succession Raghubir Singh

Pedestrians, Firozabad, Uttar Pradesh, 1992, 36 x 60 inches, © Succession Raghubir Singh

Zaveri Bazaar and Jeweler's Showroom, 1991, 36 x 60 inches, © Succession Raghubir Singh

See pages 58–61

VIVAN SUNDARAM

Re-take of Amrita – Amrita and Cousin Viola, 2001, 19 x 12 inches, courtesy of Sepia International

Re-take of Amrita – Amrita

Dreaming, 2002, 21 x 19 inches, courtesy of Sepia International

Re-take of Amrita – Bourgeois Family – Mirror Frieze, 2001, 15 x 26 inches, courtesy of Sepia International

Re-take of Amrita – Lovers, 2001, 15 x 21 inches, courtesy of Sepia International

Re-take of Amrita – Preening, 2001, 15 x 21 inches, courtesy of Sepia International

Re-take of Amrita – Remembering the Past, Looking to the Future, 2001, 15 x 21 inches, courtesy of Sepia International

Re-take of Amrita – Sisters with "Two Girls", 2001, 15 x 12.2 inches, courtesy of Sepia International

See pages 112–5

SUREKHA

The Other-Self, 2005, series of 6 digital photographs, 24 x 20 inches, courtesy of the artist

Tree Woman, 2005, single-channel video, 4:30, courtesy of the artist

See pages 70–1, 118

MANISH SWARUP

Boys in Shadow, Gujarat, 2002, 16 x 20 inches, courtesy of the artist

Cows in Burnt-out Shop, Gujarat, 2002, 20 x 16 inches, courtesy of the artist

Family through Barred Door, Gujarat, 2002, 20 x 16 inches,

courtesy of the artist

Wrestler on Floor, 2002, 16 x 20 inches, courtesy of the artist

Wrestlers on Steps, 2002, 16 x 20 inches, courtesy of the artist

Wrestlers with Rope, 2002, 16 x 20 inches, courtesy of the artist

See pages 55–7

VIVEK VILASINI

Between One Shore and Several Others, 2005, series of 7 photographs 10 x 8 inches each, with name plates, courtesy of the artist

See page 68

RAJESH VORA

Aspiring Model, Mumbai, 1998, 11 x 14 inches, courtesy of the artist

Beauty Pageant, Mumbai, 1997, 11 x 14 inches, courtesy of the artist

Hair Dresser of the Year Awards, Mumbai, 1998, 11 x 14 inches, courtesy of the artist

Look of the Year Contest, Mumbai, 1998, 11 x 14 inches, courtesy of the artist

See pages 82–3

Artist Profiles

RAVI AGARWAL (b. 1958) is a photographer and an environmentalist. His photography examines work, labor and the street within the domain of public spaces. As an environmentalist, he is founder and director of Toxics Link, an organization that collects and shares information about the sources and dangers of poisons in the environment. Agarwal's solo exhibitions include *Alien Waters* (India International Centre Gallery, New Delhi, 2006); *Down and Out* (New Delhi, Ahmedabad and Amsterdam, 2000); and *A Street View* (All India Fine Arts and Crafts Society, New Delhi, 1995). He has also participated in *Documenta 11* (Kassel, Germany 2002); *Crossing Generations: diVERGE: Forty years of Gallery Chemould* (National Gallery of Modern Art, Mumbai, 2003); *Self x Social* (School of Arts and Aesthetics, Jawaharlal Nehru University, New Delhi, 2005); and *Watching Me Watching India* (Fotografie Forum International, Frankfurt, Germany, 2006). Agarwal lives and works in New Delhi.

NAVJOT ALTAF (b. 1949) studied Fine and Applied Arts from 1967 to 1972 at Sir J.J. School of Art, Mumbai and graphics at Garhi Studios, Delhi. Since 1973, Altaf has had a number of solo and joint exhibitions in India, Germany and New York, and has been invited to participate in major national and international exhibitions such as Zones of Contact, *15th Sydney Biennale* (Australia, 2006); *Bombay: Maximum City* (Lille, France, 2006); *Ground Works* (Carnegie Mellon University, Pittsburgh, 2005); *Passage to India* (Geneva 2003–4); *Zoom – Art in Contemporary India* (Edificia Sede da Caixo Garal de Depositos, Lisbon, 2004); *Body.City: New Perspectives from India* (House of World Culture, Berlin, 2002); *In Response To* (Talwar Gallery, New York); *Three Halves* (various international venues, 2001–3); *Century City: Art and Culture in the Modern Metropolis* (the Tate Modern, London, 2001); *BBK Kunst Forum* (the Federal Association of Artists of the Fine Arts, Düsseldorf, 2001); the *First Fukuoka Asian Art Triennale* (Japan, 1999); *Women Artists from India* (various international venues 1995–7); the *Eighth International Triennale* (New Delhi, 1991); and the *Third Painting Biennale* (Bhopal, 1988). Since 1991 she has been engaged with interactive, cooperative and collaborative projects with Indian and international artists; since 1997 she has been engaged with ongoing site-specific, public art projects in collaboration with Adivasi artists and tribal communities from Bastar, in central India. Altaf lives and works in Mumbai and Bastar.

PABLO BARTHOLOMEW (b. 1955), a world-renowned photojournalist, has participated in various solo exhibitions at institutions such as the Art Heritage Gallery, New Delhi; the Jehangir Art Gallery, Mumbai; and La Musée de L'Homme, Paris. He has participated in many major group exhibitions at venues including the Photographer's Gallery, London; the Museum of Modern Art, Oxford; the International Center of Photography, New York; the Asian Art Museum, San Francisco; and the Queens Museum of Art, New York. Bartholomew has received many honors including a fellowship from the Asian Cultural Council, New York, 1987; World Press Photo Award for Picture of the Year, 1985; a World Press Photo Award, Holland, 1976; and an award from Press Institute of India: Best Young Photographer, 1975. Bartholomew is based in New Delhi.

ATUL BHALLA (b. 1964) earned his B.F.A. from the College of Art, Delhi University and his M.F.A. from the School of Art of Northern Illinois University. He is a member of Khoj, International Artists Association, a New Delhi collective that has promoted radical new media practice in India. Bhalla's exhibitions include the solo exhibitions at Anant Art Gallery, New Delhi, 2007; Khoj International Artists Association, New Delhi, 2005; and Northern Illinois University, 1990. He has also participated in group shows including *Watching Me Watching*

India (Fotographie Forum, Frankfurt, 2006) and *Self x Social* (Jawaharlal Nehru University, New Delhi, 2005). Bhalla lives and works in New Delhi.

SHAHID DATAWALA (b. 1974) a freelance photographer, worked for *India Magazine* from 1995 to 1998 and has been working for *First City*, a Delhi-based magazine, for the last four years. His solo exhibitions include *A Walk with Pillars* (Max Mueller Bhavan, New Delhi, 2001); and *Dress Circle* (Foss Gandi, Bangalore, Mumbai, Calcutta, New Delhi, 2006–7). His honors include a grant from the Ford Foundation and a grant from Sarai, a new media initiative of the Center for the Study of Developing Societies in Delhi. A multi-talented artist, Datawala is the chief designer for Palatte, a high-end furniture design store in Mumbai. He also designs jewelry. Datawala lives and works in Mumbai.

ANITA DUBE (b. 1958) received a B.A. in History from the University of Delhi in 1979, and an M.A. in Art Criticism from the Maharaja Sayajirao University of Baroda in 1982. She has participated in solo and group exhibitions including *Inside Out* (Bombay Art Gallery, Mumbai, 2007); *Lille 3000* (2006); *Illegal* (Nature Morte, New Delhi and Bose Pacia, New York, 2005); *Icon: India Contemporary* at the *Venice Biennale* (Italy, 2005); *Androgyne* (India Habitat Centre, New Delhi, 2004); *The Sleep of Reason* (Sakshi Gallery, Mumbai and Nature Morte,

New Delhi, 2003); *Kalam to Computer / Room For Improvement* (Crafts Museum, New Delhi); *ARS 01* (Kiasma Museum, Helsinki, 2001); the *Seventh Havana Biennial* (2000); and *Telling Times* (the British Council, New Delhi and Bath Festivals Trust's Contemporary Art Programme, Bath, U.K., 1998).

GAURI GILL (b. 1970) completed a B.F.A. in Applied Art in 1992 from the Delhi College of Art, New Delhi. In 1994, she earned a B.F.A. in Photography at Parsons the New School for Design, New York where she interned with Mary Ellen Mark. She finished her M.F.A. in photography at Stanford University where she was awarded one of five artists' fellowships. From 1995 to 2000 she was a photographer with *Outlook* magazine, New Delhi. Gill has pursued many editorial and curatorial projects and has been teaching photography in the American School, New Delhi since 2003. Gill has participated in exhibitions including *Women Photographers from SAARC Countries* (Italian Cultural Center, New Delhi, 2005); *Award Winners Show* (Fifty Crows Foundation, San Francisco, 2002); and *In Black and White: What Has Independence Meant for Women* (Admit One Gallery, New York, 1998). Her honors include a Fifty Crows Award; a Senior Arts Fellowship at the American Institute of Indian Studies, University of Chicago, 2002; and an award from the Anita Squires Fowler Memorial Fund in Photography,

Stanford University, 2001. Gill lives and works in New Delhi.

SHILPA GUPTA (b. 1976) studied at the Sir J.J. School of Art, Mumbai. Gaining international visibility, Gupta has come to critique the representation of Third World issues. Her solo exhibitions include shows at Apeejay New Media Gallery, Delhi; Sakshi Gallery, Mumbai, 2006; Bose Pacia Gallery, New York, 2005; *Your Kidney Supermarket* (Oxford Bookstore, Mumbai, 2004); and *Blessed Bandwidth.net* (a commission from the Tate Modern, London and Gallery Chemould, Mumbai, 2003). She has participated in the *Liverpool Biennial* (U.K.). *Biennale of Sydney* (Australia); *Avatars of the Object* (Jehangir Nicholson Gallery, Mumbai); the *Ninth Havana Biennial* (Cuba); *Subcontingente* (Fondazione Sandretto Re Rebaudengo, Torino, 2006); *Art Meets Media – Adventures in Perception* (Tokyo); the *Third Fukuoka Asian Art Triennale* (Fukuoka Asian Art Museum, Japan, 2005); *Media City, Seoul Biennale* (South Korea); *Edge of Desire: Recent Art in India* (various international venues, 2004–6); and *Century City: Art and Culture in the Modern Metropolis* (the Tate Modern, London, 2001). Gupta lives and works in Mumbai.

SUBODH GUPTA (b. 1964) completed a B.F.A. in Painting from the College of Arts and Crafts, Patna, in 1988. Gupta is internationally recognized for his

sculptural installations and works consistently in new media. His solo exhibitions include *Living for the City* (Jack Shainman Gallery, New York, 2005); *I Go Home Every Single Day* (the Showroom Gallery, London, 2004); and *This Side is the Other Side* (Art and Public, Geneva, 2003). His work has been featured in many recent major group exhibitions including *Altered, Stitched and Gathered* (P.S.1 Contemporary Art Center, New York, 2007); *Venice-Istanbul* (Istanbul Modern, 2006), *Lille 3000* (France, 2006); *Universal Experience: Art, Life and the Tourist's Eye* (Museum of Contemporary Art, Chicago, 2005); the *51st Venice Biennale* (2005); *Dialectics of Hope*, *the Moscow Biennale of Contemporary Art* (2005); *Indian Summer: La Jeune Scène Artistique Indienne* (École Nationale Supérieure des Beaux-Arts de Paris, 2005); *Edge of Desire: Recent Art in India* (various international venues, 2004–6); and the *Eighth Havana Biennale* (2003). Gupta has participated in several national and international workshops and residencies, and his awards and scholarships include a French government residency in Paris, a visiting professorship at L'École Nationale Supérieure des Beaux-Arts de Paris, 2004; an award from UNESCO-Ashberg Bursaries for Artists at Gasworks Studio, London, and an Emerging Artist Award from Bose Pacia, New York, 1997. Gupta lives and works in New Delhi.

SUNIL GUPTA (b. 1953) earned an M.A. in Photography from the Royal College of Art, London in 1983. As photographer, curator and activist, he has worked extensively to represent Indian photography at the local level as well as at international exhibitions. Gupta has been exhibited widely, and in recent years he has participated in exhibitions at the Museum Ludwig, Köln; the Hayward Gallery, London; Metro Pictures, New York; and the Bombay Art Gallery, Mumbai. His books include *An Economy of Signs: Contemporary Indian Photography* (1990); *Ecstatic Antibodies: Resisting the AIDS Mythology* (1990); *Disrupted Borders: Interventions in Definitions of Boundaries* (1993); and *Pictures From Here* (2003). He has curated and organized exhibitions since 1989 and co-researched *Click! Indian Photography Now* for the Vadehra Art Gallery, Delhi. He is the co-founder of Autograph, the Association of Black Photographers, and contributed to the formation of the Institute of International Visual Arts in London. In his role as an activist, he is a member of the Nigah Media Collective, a queer activist group, teaches photography at Bluebells School and is part of Camerawork, Delhi. Gupta lives and works in Delhi.

SAMAR JODHA (b. 1968) has worked on numerous social communication projects for the Bill and Melinda Gates Foundation, the BBC World Service Trust, Population Services International and several grassroots level organizations. His editorial work has appeared in publications as varied as *Elle*, *Time Out*, *Elle Décor*, *Conde Nast Traveler* and *USA Today*. His books include the award-winning *Jaipur: The Last Destination* (1993). His work can also be seen in *Costumes and Textiles of Royal India* and in *Dubai: 24 Hours*. His collaborations with Vijay Jodha resulted in the critically acclaimed book *Ageless Mind and Spirit* (2002). The project was presented as a traveling exhibition by the United Nations in 1999, and was the only work of contemporary art selected from the whole of South Asia to be showcased at the New Zealand International Arts Festival (2004). Jodha lives and works in Delhi.

VIJAY JODHA (b. 1966) completed his Masters in 1996 from the Department of Culture and Communication at New York University, and he studied filmmaking at the Tisch School of Arts and School of Visual Arts in New York. He has worked at MTV Networks New York and CBS Weekend News. Jodha has also completed film and television projects for a variety of clients in India and overseas, including the Smithsonian, the Discovery Channel, Doordarshan and PBS. His writings and images have appeared in a variety of publications in India and overseas. Jodha collaborated with Samar Jodha in 2005 to produce the photography book *Tiranga,* featuring the work of seventy of India's leading photographers. Jodha was

honored with the U.K. Environment Film Fellowship in 2005. Jodha lives and works in Delhi.

RANBIR KALEKA (b. 1953) received a diploma in Painting from the College of Art of Punjab University, Chandigarh in 1975 and an M.A. in Painting from the Royal College of Art, London. He taught at the Fine Arts Department of College for Women, Punjabi University, Patiala from 1976 to 1977 and at the Delhi College of Art, New Delhi from 1980 to 1985. His exhibitions include *Hungry God: Indian Contemporary Art* (Arario Gallery, Beijing and the Busan Museum, Korea, 2006), *Edge of Desire: Recent Art in India* (various international venues, 2004–6); *Icon: India Contemporary* (Venice Biennale, 2005); *After Dark* (Sakshi Gallery, Mumbai, 2004); *Body.City: New Perspectives from India* (House of World Cultures, Berlin, 2002); *Kapital and Karma* (Kunsthalle, Vienna, 2002); *Contemporary Indian Art, Royal Academy of Arts* (Festival of India, London, 1982); *India: Myth and Reality, Aspects of Modern Indian Art* (Museum of Modern Art, Oxford,1982). Kaleka received a National Award from *Lalit Kala Akademi*, New Delhi in 1979 and the Sanskriti Award in 1986. Kaleka lives and works in New Delhi.

JITISH KALLAT (b. 1974) earned a B.F.A. in Painting from the Sir J.J. School of Art, Mumbai in 1996. Since then he has had many solo shows including, *Rickshawpolis-3* (Gallery Barry Keldoulis, Sydney, 2007); *Rickshawpolis-2* (Spazio Piazzasempione, Milan, 2006); *Rickshawpolis-1* (Nature Morte, New Delhi, 2005); *Panic Acid* (Bodhi Art, Singapore, 2005); *The Lie of the Land* (Walsh Gallery, Chicago, 2004); *First Information Report* (Bose Pacia, New York, 2002). He has participated in group shows such as the *Fifth Asia Pacific Triennale of Contemporary Art* (Queensland Art Gallery and Gallery of Modern Art, Brisbane, 2006–7); *Hungry God: Indian Contemporary Art* (Arario Gallery, Beijing and the Busan Museum, Korea, 2006); *Indian Summer: La Scène Artistique Indienne* (École Nationale Supérieure des Beaux-Arts de Paris, 2005); *Crossing Generations: diVERGE: Forty years of Gallery Chemould* (National Gallery of Modern Art, Mumbai, 2003); *Under Construction* (the Japan Foundation Asia Center, Tokyo, 2002); *Century City* (the Tate Modern, London, 2001); *the First Fukuoka Asian Art Triennale* (Fukuoka Asian Art Museum, Japan, 1999). Kallat lives and works in Mumbai.

SONIA KHURANA (b. 1968) completed an M.A. in 1999 at the Royal College of Art, London. Earlier, she studied for a B.A. and M.F.A. at the Delhi College of Art, and did a short course at the Film and Television Institute of India in Pune. In 2002, she was invited for a two-year research residency at the Rijksakademie in Amsterdam. Under her recently formed initiative called Vidya-Video, Khurana uses video as a tool for collaborative and community-based projects in and around Delhi. In 2004, she traveled to Cameroon to do a video-based workshop near Douala. She later initiated similar workshops in South Africa, Thailand and, most recently, in Mexico City for the artists' initiative El Despacho. Her recent screenings and exhibitions include venues such as Arario Beijing; École Nationale Supérieure des Beaux-Arts de Paris; Apeejay Media Gallery, Delhi; Tamayo Museum, Mexico; the International Documentary Film Festival of Amsterdam; Walsh Gallery, Chicago; Thomas Erben Gallery, New York; Center D'Ethnographie, Geneva; Pusan Biennale, Korea; Fukuoka Museum of Asian Art, Japan; House of World Cultures, Berlin; National Gallery of Modern Art, Mumbai; Asia Society, New York; Art Gallery of Western Australia, Perth; Museum of Contemporary Art, Brisbane; De Balie, Amsterdam; Cornell University; Nehru Centre, London; Henie Onstad Kunssenter, Oslo; and Kunsthalle Wien, Vienna. Khurana currently lives and works in New Delhi.

SHANTANU LODH (b. 1967) earned a B.F.A. in Art History in 1993 and an M.F.A. in Painting in 1995 from Santiniketan, West Bengal. His exhibitions / performances include *Kapital and Karma* (Kunsthalle, Vienna, 2002); *Crossing Generations: diVERGE: Forty years of Gallery Chemould* (National Gallery

of Modern Art, Mumbai, 2003); *Reserve Der Form* (Künstlerhaus, Vienna, 2004); *Wild Life Garden* (Import Export, Vienna, 2005); *We Are All Naked in a Turkish Bath* (Khoj International Artists Association, New Delhi, 2005). Lodh lives and works in New Delhi.

ANNU PALAKUNNATHU MATTHEW (b. 1964) received her B.Sc. in Mathematics from the Women's Christian College, Chennai in 1986 and her M.F.A. in Photography from the University of Delaware, Newark in 1997. She has had her work included in many recent exhibitions at prestigious venues such as the Victoria and Albert Museum, London; Light Work, Syracuse, NY; Sepia International Inc., New York City; the Rhode Island School of Design Museum, Providence; in the *Noorderlicht International Photo Festival* (the Netherlands, 2006); and *Le Mois de la Photo à Montréal Biennale* (2005). Matthew has been the recipient of many recent grants including the John Gutmann Photography Fellowship; a Rhode Island State Council on the Arts Fellowship; and the American Institute of Indian Studies Creative Arts Fellowship. She was recently an artist in residence at Yaddo, an artists' community in Saratoga Springs, NY, and at the MacDowell Colony, Peterborough, NH. Matthew's work can be found in the collections of George Eastman House, Rochester, NY; the Museum of Fine Arts in Houston; the Center

for Creative Photography, Tucson, AZ; and the RISD Museum, among others. In addition, Matthew's photography is included in *BLINK,* from Phaidon Press. The book celebrates today's 100 most exciting international contemporary photographers. Matthew is an Associate Professor of Art at the University of Rhode Island in Kingston.

PUSHPAMALA N. (b.1956) attended Bangalore University from 1976 to 1977 and studied under Balan Nambiar. She later joined its faculty of Fine Arts, then studied sculpture at the Maharaja Sayajirao University of Baroda, on a Karnataka Government scholarship. She graduated in 1982 and completed her post-graduate training there in 1985. Pushpamala has received many honors, including a National Award from *Lalit Kala Akademi*, New Delhi, 1984; the gold medal at the *Sixth New Delhi Triennale*, 1986; the Charles Wallace Trust Fellowship for residency at St. Martin's School of Art, London, 1992–3; and the Senior Fellowship, Indian Ministry of Human Resource Development, 1995–7. Her first solo exhibition was at the Venkatappa Art Gallery in Bangalore, in 1983. Recent solo exhibitions include *Pushpamala N. Photo and Video Performance Work* (Espace Croise, Roubaix, France, 2006); *Native Women of South India* (Nature Morte, New Delhi, 2005); *Native Women of South India – Manners and Customs* (Sumukha Gallery, Bangalore, Gallery

Chemould, Mumbai, and Seagull Arts and Media Center, Kolkata, 2005); and *Phantom Lady* or *Kismet* (Gallery Chemould, Mumbai, 1998). She also has participated in numerous recent group exhibitions, including *Photo and Media Art from India: A Journey of Discovery* (Fotofluss, Austria, 2007); *Cinema Prayoga: Indian Experimental Film and Video 1913–2006* (the Tate Modern, London, 2006); *India Express* (Helsinki City Art Museum, Finland, 2006); *Indian Summer: La Jeune Scène Artistique Indienne* (École Nationale Supérieure des Beaux-Arts de Paris, 2005); and *Edge of Desire: Recent Art in India,* various international venues, 2004–6. Pushpamala N. lives and works in Bangalore.

RAM RAHMAN (b. 1955) is a photographer and designer who has contributed extensively to SAHMAT, a Delhi-based collective of scholars and artists dedicated to cultural pluralism and secularism. Rahman began his photographic education under Jonathan Green at M.I.T. while a physics student in the mid-1970s. He graduated with a degree in Graphic Design from the Yale University School of Art in 1979. His first major solo exhibition was at the Shridharani Gallery in Delhi in 1988. Since then, he has had solo exhibitions in New York, Amsterdam and at the Cleveland Museum of Art. His group shows include exhibitions at the Japan Foundation in Tokyo and the Photographer's Gallery in London. Rahman has also

curated many exhibitions, including a major retrospective of Sunil Janah in New York in 1998 and *HEAT*, a group show of mainly photographic and video work at Bose Pacia in New York. He has participated in symposia at the Museum of Modern Art in New York, the Tate Modern in London and at the Baroda School of Art. His work has broadly been in black and white, in a personalized documentary style. He is represented in major collections in India and around the world. Rahman lives and works in Delhi.

RAGHU RAI (b. 1942) started making photographs in 1965. In his subsequent career, he has emerged as one of India's most influential photographers. From 1966 to 1976 he served as chief photographer for *The Statesman* newspaper, and from 1977 to 1980 was picture editor for *Sunday*, a weekly news magazine published in Calcutta. In 1971, legendary photographer Henri Cartier-Bresson nominated Rai to Magnum Photos, the world's most prestigious photographers' cooperative in Paris. Rai worked as picture editor for *India Today* from 1982 to 1991. He was awarded the Padma Shri in 1971, one of India's highest civilian awards ever given to a photographer. In 1992, he was awarded Photographer of the Year in the United States for the story "Human Management of Wildlife in India" published in *National Geographic*. He has been on the jury of the World Press Photo Contest three times, and twice on UNESCO's

International Photo Contest. He has worked extensively on the photo documentation of the Bhopal Gas Tragedy and its continuing effects on the lives of gas victims, under special assignment from Greenpeace International. In the last eighteen years, he has specialized in extensive coverage of India. He has produced more than eighteen books including *India* (1985); *Taj Mahal* (1986); *Calcutta* (1989); *Khajuraho* (1991); *Tibet in Exile* (1991); *Raghu Rai's Delhi* (1992); *The Sikhs* (1984, 2002); and *Mother Teresa* (1971, 1996, 2004). Rai lives and works in New Delhi.

GIGI SCARIA (b. 1973) finished a B.F.A. in Painting at the College of Fine Arts, Thiruvananthapuram in 1995, and his M.F.A. in Painting at Jamia Millia University, New Delhi in 1998. Working in both paint and video, Scaria is deeply engaged with issues of urbanism in present-day India. His many honors include the Sanskriti Award in 2005, an Inlaks Foundation scholarship in 2002 and a Ministry of Human Resources and Development Scholarship for Visual Arts, 1995–7. Scaria has participated in exhibitions and workshops including *Where are the Amerindians?* (InterAmerica Space, Trinidad, 2005); *Dilli Dur Ast* (Delhi, 2006); *Self x Social* (School of Arts and Aesthetics, Jawaharlal Nehru University, New Delhi, 2005); *Crossing Generations: diVERGE: Forty years of Gallery Chemould* (National Gallery of Modern Art, Mumbai, 2003). Scaria lives and works in Delhi.

TEJAL SHAH (b. 1979) earned a B.A. in Photography from the Royal Melbourne Institute of Technology in 2000, and was subsequently exchange scholar at the School of the Art Institute of Chicago. Her work in video and performative photography is concerned with the politics and representation of gender and sexuality. Her solo shows include *What Are You?* (Galerie Mirchandani + Steinruecke, Mumbai and the Thomas Erben Gallery, New York, 2006); *The Tomb of Democracy* (Gallery Pruss & Ochs, Berlin, 2003); *In-Transit* (Viscom9 Gallery, Melbourne, 2000). Her group exhibitions include *Global Feminisms* (Brooklyn Museum, New York, 2007); *Sexwork – Art, Reality, Myths* (Neue Gesellschaft für Bildende Kunst, Berlin, 2006); *Bombay: Maximum City* (Lille, France, 2006); *Saturday Live* (the Tate Modern, London, 2006); *Sub-Contingent: The Indian Subcontinent in Contemporary Art* (Fondazione Sandrettoe Re Rebaudengo, Turino, 2006); *Indian Summer: La Jeune Scène Artistique Indienne* (École Nationale Supérieure des Beaux-Arts de Paris, 2005); *Zoom! The Near and the Far In Contemporary Indian Art* (Culturgest Museum, Lisbon, 2004); *14th International Electronic Art Festival-Videobrasil* (Southern Competitive Show, Sao Paulo, 2003); *Cross-Fertilization: Contemporary Indian Video Art* (Multi Media Art Asia Pacific, 2002). Shah was co-founder, organizer and curator for *Larzish*, International Film Festival of Sexuality and Gender

Plurality, India, 2003, and she contributed to *Women Video Letters; A Second Text On War – An International Initiative of Women Filmmakers*. Shah lives and works in Mumbai.

RAGHUBIR SINGH (1942–99) was a self-taught photographer who worked in India and lived in Paris, London and New York. In the early 1970s, he was one of the first photographers to reinvent the use of color at a time when color photography was still a marginal art form. In his early work, Singh focused on the geographic and social anatomy of cities and regions of India. His work on Mumbai in the early 1990s marks a turning point in his stylistic development. While photographing the metropolis, his visual language acquired a new complexity. In addition to his photographic work, Singh taught in New York at the School of Visual Arts, Columbia University, and the Cooper Union. In 1998, the Art Institute of Chicago organized a retrospective exhibition of his work, and the book *River of Colour* was published to accompany the show. Singh is represented in numerous solo and group exhibitions, among the most recent at *Lille 3000*, 2006; the National Media Museum, Bradford, UK, 2005; Sepia International, New York, 2004; and the Arthur M. Sackler Gallery, Smithsonian Institution, Washington, DC, 2003. His work is in the collections of the Tate Modern, London; the Museum of Modern Art

and the Metropolitan Museum of Art, New York; the Philadelphia Museum of Art; the Art Institute of Chicago; the Hirshhorn Museum and Sculpture Garden and the Arthur M. Sackler Gallery, Washington, DC; the Los Angeles County Museum of Art; the San Francisco Museum of Art; the Milwaukee Art Museum; Museum of Modern Art, Oxford; the Pecci Museum of Contemporary Art, Prato; the Williams College Museum of Art, Williamstown, MA; the National Media Museum and the Tokyo Metropolitan Museum of Photography.

VIVAN SUNDARAM (b. 1943) received a B.A. in Painting at the Faculty of Fine Arts at the Maharaja Sayajirao University of Baroda, and did post-diploma studies as a Commonwealth Scholar at the Slade School of Fine Art in London. In 1966, Sundaram held his first solo exhibition in New Delhi. He has since had numerous solo exhibitions in New Delhi, Baroda, Mumbai, Kolkata, Bangalore, Chennai, London, Montreal, Winnipeg, Vancouver and New York. A selection of his numerous group shows includes *Amrita Sher-Gil* (the Tate Modern, London, 2007); *Why Pictures Now: Photography, Film, Video* (Museum of Modern Art, Vienna, 2006); the *Second International Biennial of Contemporary Art* (Seville, 2006); *The Edge of Desire: Recent Art In India* (various international venues, 2004–6); *Indian Video Art: History in Motion* (Fukuoka Asian Art Museum,

Japan, 2004); the *Shanghai Biennale* (2004); CC: *Crossing Currents: Video Art and Cultural Identity* (Lalit Kala Akademi Galleries, New Delhi, 2004); *Science Fictions* (Singapore, 2003); *Kapital and Karma: Contemporary Indian Artists* (Kunsthalle, Vienna, 2002); *Amrita Sher-Gil and Vivan Sundaram* (Ernst Museum, Budapest, 2001); *Century City: Art and Culture in the Modern Metropolis* (the Tate Modern, London, 2001); *Icons of the Millennium* (Lakeeren Art Gallery, Mumbai, 1999); *Private Mythology: Contemporary Art from India* (Japan Foundation, Tokyo,1998); the *Second Johannesburg Biennale* (1997); the *Second Asia-Pacific Triennale of Contemporary Art* (Brisbane, 1996); the Second and Fourth Biennale, Havana (1987 and 1991); *Contemporary Indian Art* (Festival of India, London, 1982); *Six Who Declined to Show in the Triennale* (New Delhi, 1978). Sundaram lives and works in New Delhi.

SUREKHA (b. 1965) studied art at Ken School of Arts, Bangalore and at Santiniketan, West Bengal. Her works revolve around issues of gender identity and established notions of gender politics. Surekha has held many international residencies, and her works have been shown extensively in galleries and museums in India and abroad. Her major exhibitions include participation in *Diva-2006* (New York / Paris); and *Ghosts in the Machine and Other Fables* (Apeejay

Media Gallery, New Delhi, 2006); *Indian Summer: La Scène Artistique Indienne* (École Nationale Supérieure des Beaux-Arts de Paris, 2005); *Self–Contemporary Video Art from India* (Institute of Modern Art, Brisbane, 2002); *On this Side of the Sky* (UNESCO, Paris, 2003); *Sites of Recurrence* (Dakshinachitra, Chennai and the Boras Museum, Sweden, 2003); *Crossing Generations: diVERGE* (Chemould Gallery, Mumbai, 2003); *Rights / Rites / Rewrites* (Cornell University, Ithaca, NY, 2005); *Another Passage to India* (Ethnographic Museum, Geneva, 2004); *Complexities of Life* (Aboa Arsanova Museum, Turku, 2004). She is also engaged with a city project *Communing with Urban Heroines*. Surekha lives and works in Bangalore.

MANISH SWARUP (b. 1968) is an accredited photojournalist working with the Associated Press, New Delhi. He has covered war-torn Iraq and traveled to post-war Kosovo in Yugoslavia and Kabul, Afghanistan. Swarup has extensively covered conflict zones in South Asia, and he covered the 2004 tsunami devastation from Port Blair, India. Some of his other work within India includes coverage of militancy in Kashmir, the earthquake in Gujarat, floods in Orissa, the Kumbh Mela at Allahabad, and Indian politics. He also has built a photo document of masters of classical Indian music. Swarup won the Best Photograph Award on the Kargil war from the Government of India, a second prize from the International Committee of the Red Cross for best picture depicting *Human Dignity In War*, and several prizes and awards for his 1997 photographs on fifty years of Indian Independence. In May 2004, he held a solo exhibition of his photographs at the Shridharani Art Gallery, New Delhi, and has since contributed to several photography volumes on India. Swarup lives and works in New Delhi.

VIVEK VILASINI (b. 1964) graduated as a Marine Radio Officer from the All India Marine College, Kochi in 1984. He studied political science at Kerala University and later trained in sculptural practices with traditional Indian craftsmen. Vilasini has participated as a sculptor and a photographer in several group shows including *Arts for Peace* (New York, 2007); *Rock* (Art Resource Trust, Mumbai, 2006); *Waging Peace* (Hera Art Gallery, Wakefield, Rhode Island, 2006); *Double Enders* (Mumbai, Delhi, Bangalore and Kochi, 2005); and *Photographic Exhibition* (Sharjah Art Museum, Dubai, 1997). Vilasini lives and works in Bangalore.

RAJESH VORA (b. 1954) studied Visual Communication at the National Institute of Design, Ahmedabad and started his career as a graphic designer. Since 1990, he has worked as an independent editorial and documentary photographer, focusing on issues related to rapid cultural change and subsequent cultural losses. His concern with urban issues and the environment has led him to work in collaborative projects with architects, filmmakers and environmentalists. For over a decade, Vora has contributed to *Colors* magazine as photographer, idea contributor and writer. He has also participated in projects of *Fabrica*, a visual arts organization in Brighton, U.K. and has contributed to photography books on urban issues and architecture. His group exhibitions include *Another Asia* (Noorderlict Photo Festival, the Netherlands, 2006); *Bombay, Maximum City* (France, 2006); *Middle Age Spread: Imaging India 1947–2004* (National Museum, New Delhi, 2004); *International Photography Biennale* (Santa Cruz de Tenerife, Canary Islands, 2005); *Woman / Goddess* (New York and India, 1998–2001). Vora lives and works in Mumbai.

Select Bibliography

Anita Dube. New York: Bose Pacia, 2005.

Bayly, C.A., ed. *A Shifting Focus: Photography in India, 1850–1900*. London: The British Council, 1990.

Bayly, C.A., ed. *The Raj: India and the British, 1600–1947*. London: National Portrait Gallery, 1990.

Boffin, Tessa and Sunil Gupta, eds. *Ecstatic Antibodies: Resisting the AIDS Mythology*. London: Rivers Oram Press, 1990.

Castelli, Enrico and Giovanni Aprile. *Divine Lithography*. Pune: United Multicolour Printers Pvt. Ltd., 2005.

Chandrasekhar, Indira and Peter C. Seel, eds. *Body.City: Siting Contemporary Culture in India*. Berlin and New Delhi: House of World Cultures and Tulika Books, 2003.

Chatterjee, Partha. *The Partha Chatterjee Omnibus: Nationalist Thought and the Colonial World, The Nation and its Fragments, A Possible India*. New Delhi: Oxford University Press, 1999.

Cotter, Holland. "Visions of India: Sensual and Dark," *New York Times*, July 28, 1997, C24.

Das, Veena. *Critical Events – An Anthropological Perspective on Contemporary India*. Oxford: Oxford University Press, 1995.

Dehejia, Vidya, ed. *India Through the Lens: Photography 1840–1911*. Washington, DC: Freer Gallery of Art and Arthur M. Sackler Gallery, Smithsonian Institution, 2001.

Dehejia, Vidya, ed. *Representing the Body – Gender Issues in Indian Art*. New Delhi: Kali for Women, 1997.

Documenta 11 – Platform 5: Exhibition Catalogue. Germany: Hatje Cantz Verlag, 2002.

Fitz, Angelika, Gerald Matt and Michael Wörgötter, eds. *Kapital and Karma: Aktuelle Positionen Indischer Kunst / Recent Positions in Indian Art*. Ostfildern-Ruit, Germany: Hatje Cantz Publishers, 2003.

Gadihoke, Sabeena. *India in Focus: Camera Chronicles of Homai Vyarawalla*. New Delhi and Ahmedabad: UNESCO / Parzor Foundation and Mapin Publishing, 2005.

Gandhi, M.K. *The Essence of Hinduism*. Ahmedabad: Navjivan Publishing House, 2002.

Goldberg, Vicki, ed. *Photography in Print*. Albuquerque: University of New Mexico Press, 1988.

Guha, Ranajit, ed. *Subaltern Studies VI, Writings on South Asian History and Society*. Oxford: Oxford University Press, 1998.

Gupta, Sunil, ed. *An Economy of Signs: Contemporary Indian Photographers*. London: Rivers Oram Press, 1990.

Gupta, Sunil, ed. *Disrupted Borders*. London: Rivers Oram Press, 1993.

Gupta, Sunil, *Pictures from Here*. London: Chris Boot Ltd., 2003.

Gutman, Judith Mara. *Through Indian Eyes*. New York: Oxford University Press and the International Center of Photography, 1982.

Horne, Peter and Reina Lewis, eds. *Sexualities and Visual Culture*. London: Routledge, 1996.

Icon: India Contemporary. New York: Bose Pacia, 2005.

India: A Celebration of Independence, 1947–1997. New York: Aperture Foundation, 1997.

Indian Summer: La Jeune Scène Artistique Indienne. Paris: Ecole Nationale Supérieure des Beaux-Arts de Paris, 2005.

Indian Women Photographers. Photographers International: Taipei, Taiwan, December 1997.

Jhaveri, Amrita. *A Guide to 101 Modern and Contemporary Indian Artists*. Mumbai: India Book House, 2005.

Jones, Amelia, ed. *The Feminism and Visual Culture Reader*. London: Routledge, 2003.

Kapur, Geeta. *When Was Modernism. Essays on Contemporary Cultural Practice in India*. New Delhi: Tulika Press, 2000.

Kaur, Raminder and Ajay J. Sinha, eds. *Bollyworld – Popular Indian Cinema through a Transnational Lens,* New Delhi: Sage Publications India Pvt. Ltd., 2006.

Lokhandwala, Arshiya. *Rites / Rights / Rewrites: Women's Video Art from India*. Durham, North Carolina: John Hope Franklin Center for Interdisciplinary and International Studies, Duke University, 2005.

Michael, Tobias and Raghu Rai. *A Day in the Life of India*. New York: HarperCollins,1996.

Mirzoeff, Nicholas, ed. *The Visual Culture Reader*. London: Routledge, 2002.

Nagy, Peter. "Subodh Gupta," *Sidewinder*. Kolkata: CIMA Gallery, 2002.

Nalini Malani: Stories Retold. New York: Bose Pacia, 2004.

Neumayer, Erwin and Christine Schelberger. *Popular Indian Art – Raja Ravi Varma and The Printed Gods of India*. New Delhi: Oxford University Press, 2003.

Out of India: Contemporary Art of the South Asian Diaspora. New York: Queens Museum of Art, 1997.

Parekh, Bhikhu. *Colonialism, Tradition and Reform – An Analysis of Gandhi's Political Discourse*. New Delhi: Sage Publications India Pvt. Ltd., 1999.

Pijnappel, Johan, ed. *Crossing Currents: Video Art and Cultural Identity*. New Delhi: Royal Netherlands Embassy and The Mondriaan Foundation, 2006.

Pinney, Christopher. *Camera Indica: The Social Life of Indian Photographs*. Chicago: University of Chicago Press, 1997.

Pinney, Christopher. *Photos of the Gods: The Printed Image and Political Struggle in India*. London: Reaktion Books, 2004.

Private Mythology: Contemporary Art from India. Tokyo: Japan Foundation, 1998.

Pushpamala N: Dard-e-Dil: The Anguished Heart. New Delhi: The Queen's Gallery, The British Council, 2003.

Pushpamala N: Indian Lady. New York: Bose Pacia, 2004.

Raghu Rai's India – A Retrospective. Tokyo: Asahi Shimbun, 2001.

Rai, Raghu. *A Day in the life of Indira Gandhi*. Bombay: Nachiketa Publications, 1974.

Rai, Raghu. *Dreams of India*. Singapore / San Francisco, Time Books International / Collins Publishers, 1988.

Rai, Raghu. *Romance of India*, New Delhi: Timeless Books, 2005.

Rai, Raghu. *Indira Gandhi: A living legacy*. New Delhi: Timeless Books, 2004.

Ram Rahman: Photographs. New Delhi: Shridharani Gallery, 1988.

Ranbir Kaleka: Crossings. New York: Bose Pacia, 2005.

Said, Edward W. *Culture and Imperialism*. London: Vintage, 1993.

Said, Edward W. *Orientalism – Western Conceptions of the Orient*. London: Penguin Books Ltd., 1995.

Sambrani, Chaitanya, Kajri Jain and Ashish Rajadhyaksha, eds. *Edge of Desire: Recent Art in India*. London: Philip Wilson Publishers, 2005.

Sangari, Kumkum and Sudesh Vaid, eds. *Recasting Women – Essays in Colonial History*. New Delhi: Kali for Women, 1993.

Sheth, Ketaki. *Twinspotting: Photographs of the Patel Twins in Britain and India*. Stockport, England: Dewi Lewis Publishing, 1999.

Shilpa Gupta. New York: Bose Pacia, 2006.

Singh, Dayanita. *Myself Mona Ahmed*. Zurich, Switzerland: Scalo, 2001.

Singh, Dayanita. *Privacy*. Göttingen, Germany: Steidl, 2003.

Singh, Khushwant and Raghu Rai. *The Sikhs*. New Delhi: Lustre Press, 1984.

Singh, Raghubir. *A Way Into India*. New York: Phaidon Press, 2002.

Singh, Raghubir. *Bombay: Gateway of India*. New York: Aperture Foundation, 1994.

Singh, Raghubir. *Calcutta*. Hong Kong: Perennial Press, 1975.

Singh, Raghubir. *Ganga: Sacred River of India*. Hong Kong: Perennial Press, 1974.

Singh, Raghubir. *Kashmir: Garden of the Himalayas*. London and New York: Thames & Hudson, 1983.

Singh, Raghubir. *Kerala: The Spice Coast of India*. London and New York: Thames & Hudson, 1986.

Singh, Raghubir. *Photographs: India and Britain*. Bradford, England: National Museum of Photography, Film and Television, 1986.

Singh, Raghubir. *River of Colour: the India of Raghubir Singh*. New York: Phaidon Press, 2006.

Singh, Raghubir. *The Grand Trunk Road: A Passage Through India*. New York: Aperture Foundation, 1997.

Sinha, Gayatri, ed. *Indian Art: An Overview*. New Delhi: Rupa & Co., 2003.

Sinha, Gayatri. *Middle Age Spread: Imaging India, 1947–2004*. New Delhi: Anant, 2004.

Sinha, Gayatri and Celina Lunsford. *Watching Me Watching India*. Frankfurt: Fotography Forum, 2006.

Sinha, Gayatri. *Woman / Goddess: An Exhibition of Photographs*. New Delhi: Multiple Action Research Group, 1999.

Sontag, Susan, ed. *A Roland Barthes Reader*. London: Vintage Classics, 1993.

Spivak, Gayatri Chakravorty and Ranajit Guha, eds. *Selected Subaltern Studies*, New York: Oxford University Press, 1988.

Srivatsan, R. *Conditions of Visibility: Writings on Photography in Contemporary India*. Calcutta: STREE, 2000.

Thapar, Romila. *Cultural Pasts – Essays in Early Indian History*. New Delhi: Oxford University Press, 2004.

Thomas, G. *History of Photography in India 1840–1980*. Hyderabad: Andhra Pradesh State Academy of Photography, 1981.

Véquaud, Yves. *Henri Cartier-Bresson en Inde*. Paris: Centre National de la Photographie, 1985.

Video Art in India. Calcutta: Apeejay Press, 2003.

Vivan Sundaram: Memorial, an Installation of Photographs and Sculpture. New Delhi: AIFACS Galleries, 1993.

Vivan Sundaram: Re-take of Amrita. New Delhi: Tulika Books, 2001.

Vivan Sundaram: Re-take of Amrita. New York: Sepia International and the Alkazi Collection, 2006.

Vivan Sundaram: The Sher-Gil Archive. Budapest: Mücsarnok's Dorottya Gallery, 1995.

Worswick, Clark, ed. *Princely India: Photographs by Raja Deen Dayal, 1884–1910*. New York: Pennwick Publishing, 1980.

Worswick, Clark, and Ainslee Embree. *The Last Empire: Photography in British India, 1855–1914*. Millerton, New York: Aperture Foundation, 1976.

Advisory Committee

for

INDIA: Public Places, Private Spaces — Contemporary Photography and Video Art

Mr. / Mrs. Arvind and Alka Agarwal

Ms. Anna Aschkenes

Ms. Marina Budhos

Dr. Maya Chadda

Mr. Aseem Chhabra

Mr. Upendra Chivukula

The Honorable Neelam Deo

Ms. Shweta Dhadiwal

Drs. Umesh and Sunanda Gaur

Mr. Sagil George

Mr. Udayan Gupta

Mr. Praveen Kumar

Dr. Neena Malhotra

Mr. Paul Marok

Mr. / Mrs. Ravi and Kamlesh Mehrotra

Ms. Lavina Melwani

Ms. Pooja Midha

Mr. Rohit Modi and Ms. Shelley Becker

Dr. Bharati Palkhiwala

Ms. Zeyba Rahman

Ms. Daryl Rand

Ms. Shilpa Shah

Ms. Aroon Shivdasani

Mr. Jay Shroff

Mr. / Mrs. Rohit and Isha Vyas

Ms. Bethany Widrich

Trustees of
The Newark Museum Association 2007

The Newark Museum Advisory Council 2007